WEYMOUTH
THROUGH TIME

Debby Rose

AMBERLEY PUBLISHING

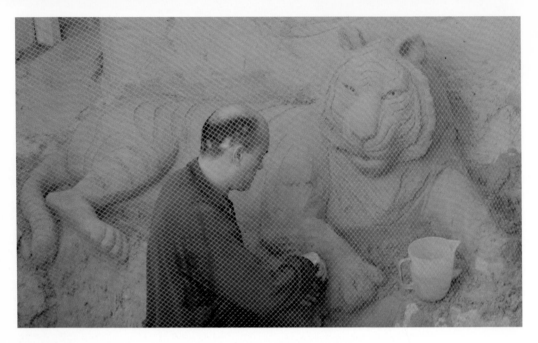

Mark Anderson, Weymouth's Sand Sculptor creating the tiger especially for *Weymouth Through Time*.

Dedicated to the memory of my grandfather, William Sidney Harris, born at Wyke Regis, who taught me an appreciation of Weymouth's history.

First published 2008

Amberley Publishing Plc
Cirencester Road, Chalford,
Stroud, Gloucestershire, GL6 8PE

www.amberley-books.com

British Library Cataloguing in Publication Data.
A catalogue record for this book is available from the British Library.

ISBN 978 1 84868 069 2

Typesetting and Origination by Amberley Publishing.
Printed in Great Britain.

Introduction

Weymouth's history begins with the twin towns and ports of Weymouth on the south side of the harbour and Melcombe Regis on the north. The trading rights of the harbour were often in dispute and in an effort to bring them together, Queen Elizabeth I united the two by Royal Charter in 1571 to form the Borough of Weymouth and Melcombe Regis. It is within these boundaries as extended in 1933 to include the surrounding villages of Wyke Regis, Radipole, Broadwey and Upwey, and Preston and Sutton Poyntz, that this book records some of the photographic history of the last hundred years or so.

The port of Melcombe Regis has the dubious honour of being the place where the bubonic plague, known as the Black Death, entered England in 1348, resulting in the decimation of the population of England. It is this side of the harbour that is best known as Weymouth, despite the name originating on the other side. For here it is that the development of a fashionable seaside resort began to take place in the second half of the 18th Century.

Ralph Allen, a wealthy man through his development of a national postal system and owner of quarries in Bath, took up summer residence on the Weymouth side of the harbour from 1750 at what is now 2 Trinity Street. He entertained many visitors, including the future King's brother, the Duke of York. The first Assembly Rooms opened on this side and one of its visitors was another brother of the King, the Duke of Gloucester. Their decline brought about by the opening of new Assembly Rooms on the Melcombe side, they had closed by 1785 and were thereafter known as the Old Rooms.

In 1773 a new hotel opened on the Esplanade, the proprietor of which was a Mr. Stacie and the hotel took his name. The hotel included new Assembly Rooms and was later to become the Royal Hotel. In 1780, the Duke of Gloucester built his summer residence, Gloucester Lodge nearby and this was later purchased by his brother, King George III who had been staying there during his early visits to Weymouth.

King George, suffering bouts of ill health, often came to Weymouth to 'take the waters' as the physicians of the time recommended them for almost every ailment. Their recommendations consisted of not only bathing in the sea water, but drinking it too. One of the first bathing machines, small huts on wheels, was used by the King, being wheeled into the water to allow for a discreet entry. On emerging, a band struck up 'God Save the King' and it was with much delight that the townspeople always welcomed the King as he brought with him prosperity and recognition for the seaside town.

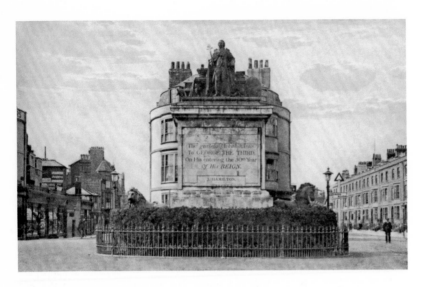

The King's Statue, erected in 1810 by public subscription to commemorate the 50 years of the reign of George III

He is also known to have frequented the well at Upwey, to attend functions at Radipole and to inspect his troops at Radipole Barracks on the Dorchester Road.

Building went on apace as more and more wealthy visitors flocked to Weymouth, requiring more entertainment facilities. The Esplanade became the hub of activity with the Theatre Royal, Harvey's Library and Assembly Rooms and various other venues of entertainment. It is no coincidence that the terrace names along the Esplanade have royal connections, being named after the King's various relatives. So grateful were the inhabitants to King George, that a monument to him was erected by public subscription in 1810 to mark his Golden Jubilee and stands proudly at the junction of St. Mary Street with St. Thomas Street, surveying the Esplanade.

The East Indiaman, the Earl of Abergavenny, sank in Weymouth Bay, one and a half miles from the beach, after striking the Shambles bank off Portland in February 1805. Its captain, John Wordsworth, who along with some 250 or more crew and passengers went down with his ship, was the brother of the Poet Laureate, William Wordsworth. He lies buried in the churchyard of Wyke Regis.

The Great Gale of 23rd November 1824 wreaked havoc along the Dorset coast and fifteen ships were wrecked in one night. The village of Fleet was almost washed away and Weymouth Esplanade was destroyed. A plaque recording this event is built into the seaward wall of the Tourist Information Centre.

By the 1830s another local sulphur spring had been discovered at Radipole and with the one already existing at Nottington, business began to boom with the building of Spa houses to accommodate their patrons. The Spas were extolled for their healing virtues and water could be bought in bottles to consume at home. The height of luxury was the steam baths, equivalent to today's saunas.

The coming of the railway to Weymouth in 1857 heralded a new era of visitors to the town and in 1865 the line was extended, running down Commercial Road as far as the harbour embarkation point for the Channel Islands ferries, where a steam packet service had been established as early as 1794.

Weymouth's growth continued in the late nineteenth and early twentieth Century with more entertainments laid on for visitors by the creation of various gardens, the erection of bandstands and theatres. During the Second World War, Weymouth featured prominently as an embarkation point for the troops involved with the D-Day landings in Normandy. It is the only port to have hosted the start of the Tall Ships Race three times and is, with Portland, to be the location of the 2012 Olympic sailing events. Indeed, history is being made once again as the Borough prepares for that event, with redevelopment of the Pavilion Pier due to commence soon, along with refurbishment of the seafront and the new Dorchester to Weymouth relief road already begun. The landscape will change dramatically and several of the present-day photographs contained herein, will become tomorrow's history before very long.

Debby Rose

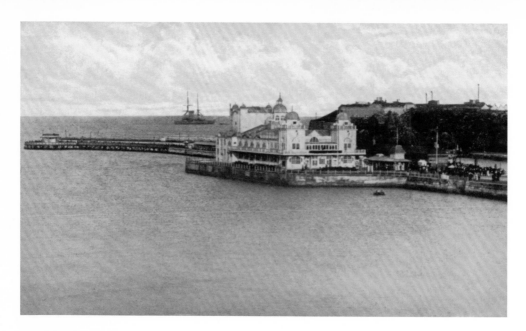

Beside the Sea

The pleasure pier was first created by reclamation from the sea in the early nineteenth century and by 1823 the pier ran just a short distance from Devonshire Buildings. It was gradually extended thereafter and in 1859 was rebuilt and extended again, this time curving at the end. Visitors could enjoy a walk along its length and berths were provided for the steamers. The length of the pier was 1050 feet in 1930 and in 1931, the first major works since 1859 were carried out when it was reconstructed using reinforced concrete. It was extended by a further 300 feet out to sea and widened, providing leisure facilities for visitors. On 13 July 1933, the new pier was opened by the Prince of Wales. During the war it was used for the embarkation of troops for the D-Day landings in Normandy. Four acres more were reclaimed from the sea in 1977 to provide further facilities for the car ferries and it was only on completion in the 1980s that land was gained at the rear of the Pavilion and on the bay side too. The pier is now on the brink of major redevelopment.

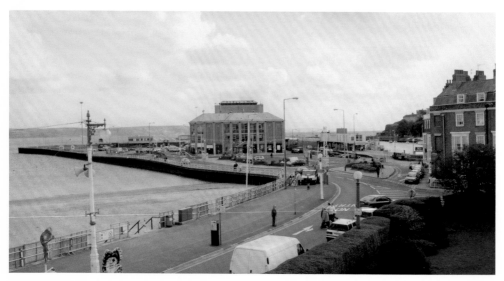

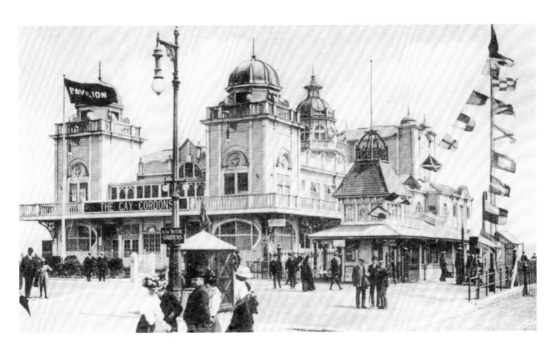

The first Pavilion Theatre was built on a piece of reclaimed land adjoining the pier, surrounded on three sides by the sea. It was constructed mainly of wood in an elegant, far-eastern, but typical seaside style and was opened on 21 December 1908 by the Earl of Shaftesbury. A skating rink was opened in 1909, which by 1930 had become the Royal Palm Court ballroom, said to be one of the finest on the South Coast. Requisitioned during the war, the Pavilion didn't reopen until 1950 and then under new name 'The Ritz'. A disastrous fire broke out on 13 April 1954 during refurbishment for the summer season and completely destroyed it. For several years the site remained empty until the construction of the present Pavilion began in late 1958 and was opened by Mayor Edgar Wallis on 15 July 1960, with the first performance being by Benny Hill. Before too long, the Pavilion is to change again with the redevelopment of the pier.

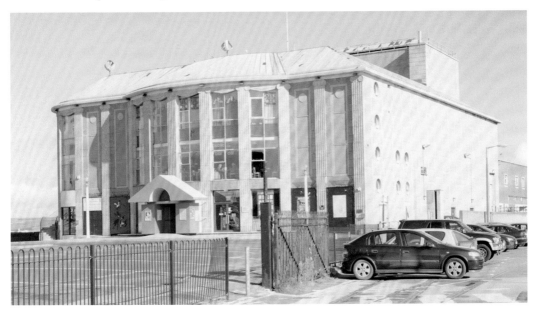

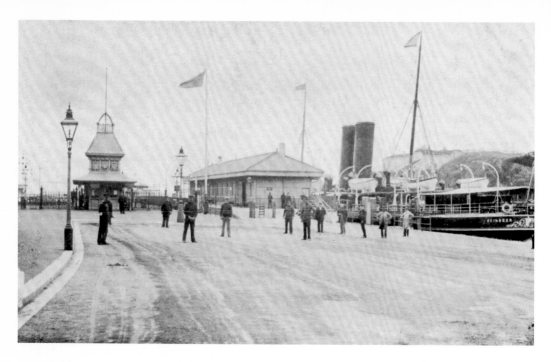

A packet steamer service to the Channel Islands was launched by the Post Office in 1794 and it began to take passengers too. However, in 1845 that service was lost to Southampton but by 1857 the Weymouth and Channel Islands Steam Company had begun a new service. The Weymouth Harbour Tramway opened in 1865 with the line extended from the railway station, along Commercial Road and so to the harbour. In 1889 the tramway was extended onto the pier where a landing stage, baggage facilities and customs offices were added. A new passenger terminal was opened in 1967 and a service to the Channel Islands continues to operate today. The ornate little building of the original pier entrance survived the fire of 1954 but was demolished shortly after the present Pavilion was built.

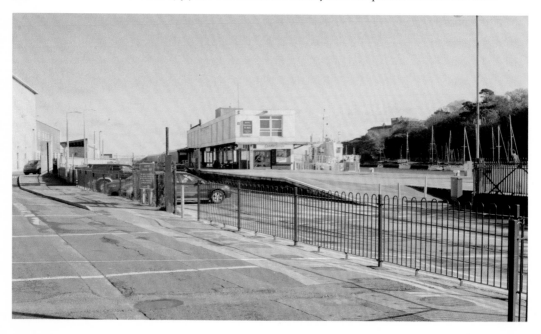

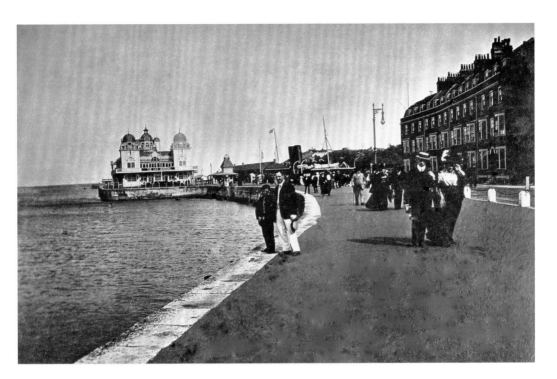

The construction of the slightly concave, three-storey, Devonshire Buildings (1-6 Esplanade) took place in 1805 on reclaimed land. The last one in the row was subsequently altered in 1819 by its builder, Mr Welsford, to finish with a rounded end, in keeping with the other rounded ends of Johnstone Row at the junction of the Esplanade with St. Mary Street that had been completed in 1811 and the round house added in 1815 and that of Coburg Place completed in 1815. The row starts and ends with a double fronted house while those in between are single and all have views of the harbour to the rear, with the Esplanade to the front.

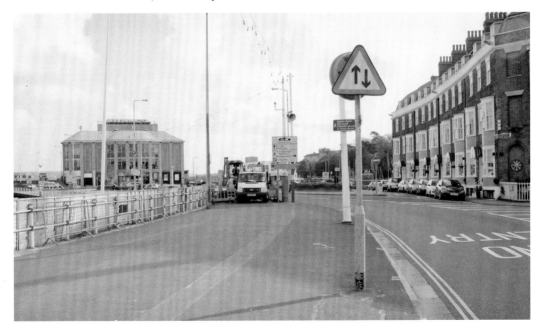

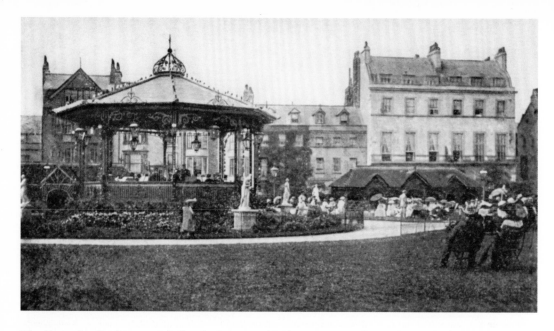

The Alexandra Gardens, named after the Princess of Wales, were created out of the reclaimed land that had been known as 'the rings' and bought by the council from a donation given by a wealthy visitor, George Stephenson. An enclosing wall was built by Charles Jesty in 1868 with railings and gates by Daniel Collet and the gardens completed and opened in 1869. The original bandstand of 1869 was a canvas shelter, but in 1891 a proper bandstand was erected. The gardens were adorned by various statues in 1898 and in 1904 by the addition of thatched shelters. Behind the gardens, the Hotel Rex, part of Clarence Buildings, was built of Portland stone *c*.1795 as two houses, although the interior is as one large house. It was the summer home of William, Duke of Clarence, a son of George III, who later became King William IV, known for his involvement in the abolition of slavery.

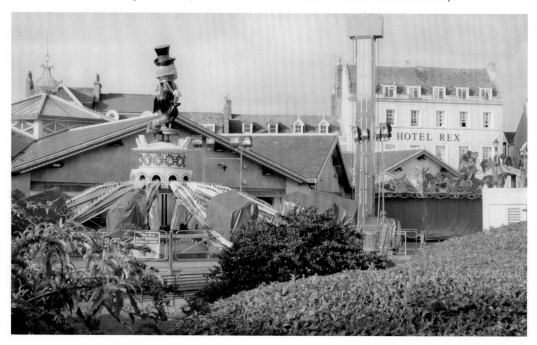

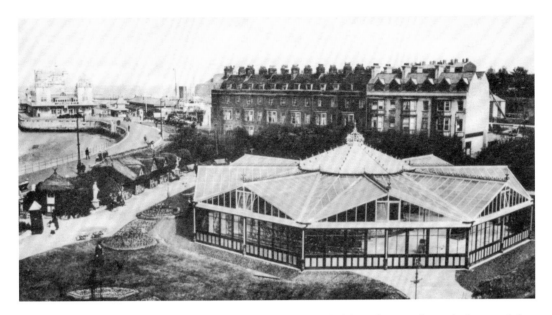

The Kursaal in Alexandra Gardens with a glass canopy and sliding glass panels was built around the bandstand in 1913 and afforded protection from the elements for the crowds that gathered to hear the bands play. It became known as Weymouth's Crystal Palace. During the First World War it was used as a reception point for the injured ANZAC troops arriving from the Gallipoli Campaign before going to camps at Chickerell and Westham. In June 1924, the original bandstand was removed to the Nothe Gardens when the Alexandra Concert Hall was built in its place. Used again during the Second World War for various functions and reopening in 1945, the Hall continued in use up until 1963 when it was closed. At this point it was taken over by Holland's, the amusement company and in 1993 it caught fire and burned down. The building erected in its place and in use today, has a roofline that resembles the old Kursaal of 1913.

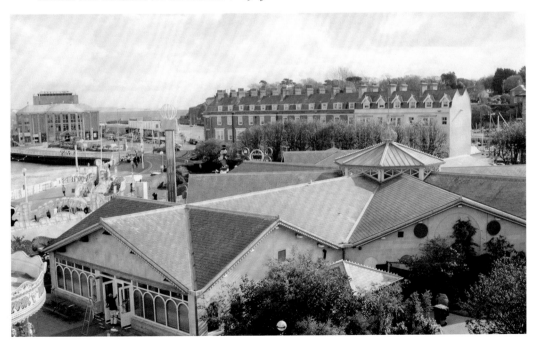

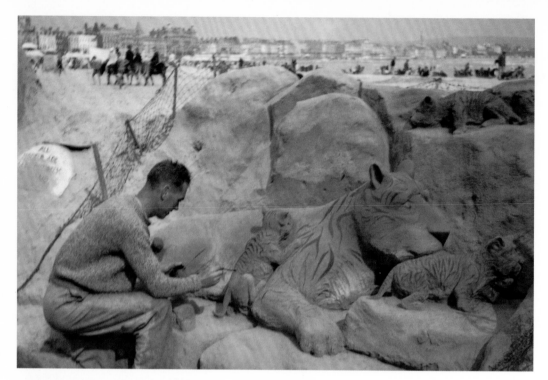

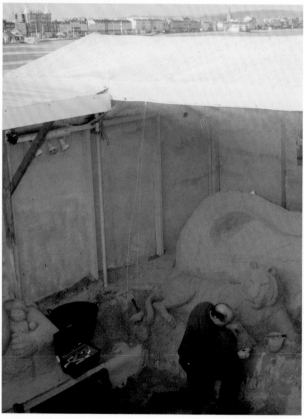

There were several sand sculptors operating on Weymouth beach during the 1920s and amongst them was one who was set to become known the world over. He was Fred Darrington (1910-2002) who was entirely self-taught and delighted the crowds with his sculptures. In the late 1970s, Fred's grandson, Mark Anderson, began helping his grandfather, initially by running errands but gradually learning his grandfather's skills and in 1988 became an apprentice. One day Mark arrived at the seafront to find that Fred had changed the sign to read: 'Sand Sculptures by F G Darrington & Grandson' and that was a very proud moment for him. Fred continued to have visitors awestruck with his sculptures up until 1996 when at the age of 86, he suffered a stroke and retired. He died in 2002, but his legacy lives on in Mark who is now Weymouth's only sand sculptor and like his grandfather, is internationally known for his art.

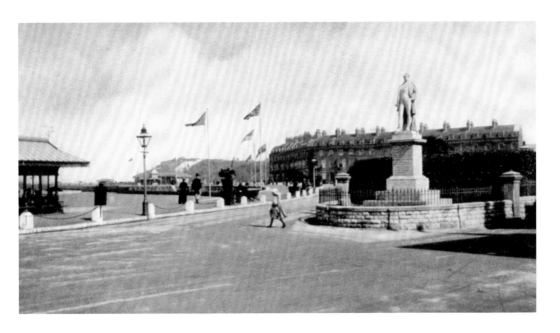

At the northern end of Alexandra Gardens, a statue of Sir Henry Edwards (1820-1897) stands surveying the Esplanade. The statue was erected in 1886 to commemorate a man who had not only been an MP for Melcombe Regis between 1867 and 1885, but who was a great benefactor to the people of the town. In 1887, when the Jubilee Clock was in the course of erection, funds ran out to provide the clock, so Sir Henry Edwards did so. He provided almshouses on Boot Hill and Rodwell Avenue, a new clock for the Old Town Hall and the building of the Working Men's Club in Mitchell Street, amongst other things. The cast iron seafront shelters were erected in 1889 and had balconies, as this one still has, but the rest have lost theirs by widening of the Esplanade.

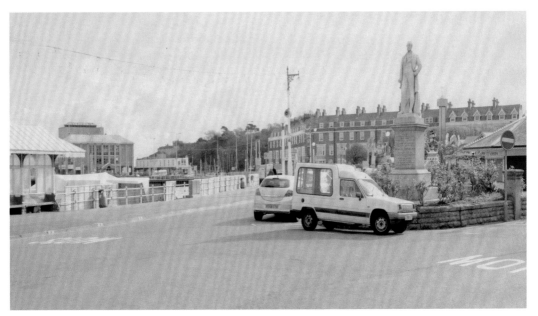

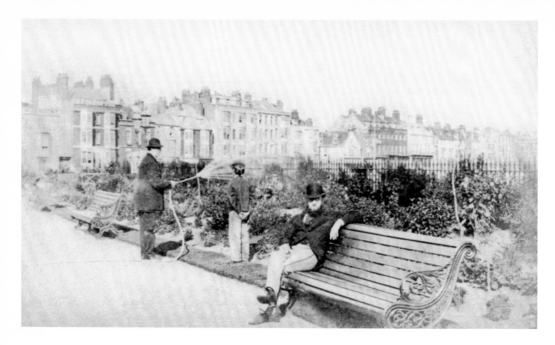

The skyline of the buildings along the Esplanade at this point has changed a lot with alterations made. The corner building of Grosvenor Place where it meets East Street was in 1875 the premises of W J Vincent, a fruiterer. Augusta Place (35-46 Esplanade), the first terrace after, was built c.1795 and within it was Luce's Hotel which became the Queen Victoria Hotel, then the Fairhaven Bars and is now known as the New Vic. The Weymouth Hotel had its excessively tall gable added sometime around the turn of the last century. Two small houses, one a draper's shop, stood on the corner of Bond Street where the elegant building of the former bank of 1883 has since been converted to public toilets. Charlotte Row c.1795 (47-51) follows with the Dorothy Inn and the former Harvey's Library which is now a nightclub.

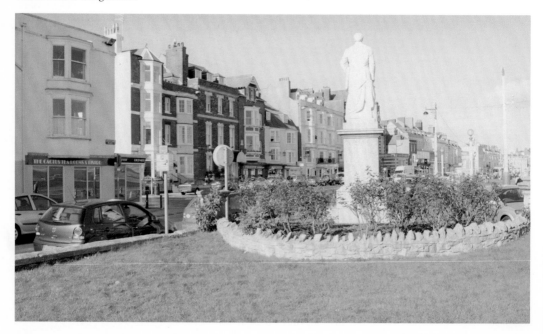

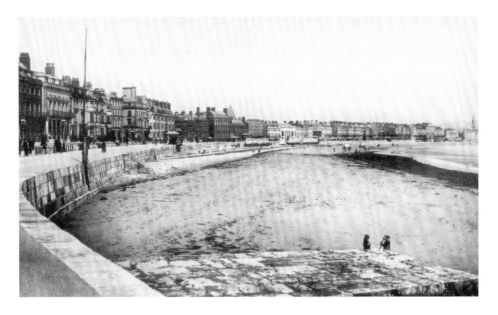

Harvey's Library (51 Esplanade) with its splendid arches and columns, was frequented by the Royal family on their visits to Weymouth. It had with it card and Assembly Rooms and from here, John Harvey published his Weymouth guide in 1800, giving the rules of conduct for prospective patrons. Around the 1840s it became known as Thomas's Library. The building of York Buildings (52-57) began in 1783 and was the first terrace built to face the sea. Its end house was demolished in the 1950s. The rear of Marks & Spencer was once partly filled by three large, four-storey houses, built c.1796 and called Chesterfield Place. In the 1950s, the store extended its premises in St. Mary Street back towards the seafront by demolishing the upper floors of the first house and rebuilding the first floor to match with the alterations they had already made to the ground floor. The other two buildings were rebuilt by Barclays Bank when they extended their premises back towards the seafront.

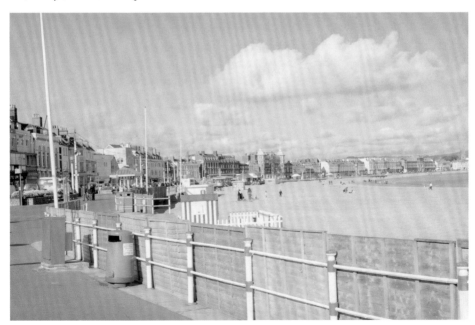

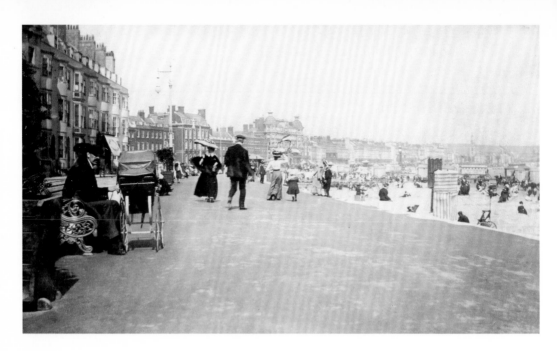

Sir William Pulteney was granted a lease in 1796 for the land on which Chesterfield Place was built and later Johnstone Row (61-67), a terrace of 6 houses that was completed in 1811. The round house at the end of the terrace, known as Statue House, was added in 1815 at the same time that Coburg Place was completed with its matching round house at the end. Here the two meet at the northern end of St. Mary Street by the King's Statue. This part of the beach was and still is the area where the Punch and Judy shows would take place and a little further on, the bathing machines, at first, small and singular in an octagonal shape that gave way to the much larger bathing saloons. The first mention of such in Weymouth was in 1748, some forty years before King George III arrived for his first sampling of the sea.

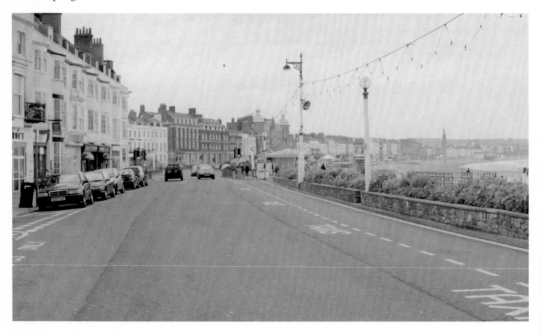

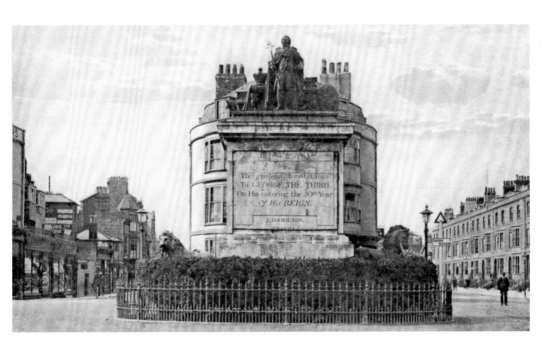

Looking down the Esplanade is the King's Statue, erected in 1810 by public subscription to commemorate the 50 years of the reign of George III. The architect was James Hamilton who was responsible for much building around the seafront. Behind the statue, is the meeting point of the two main streets of the town, St. Mary Street and St. Thomas Street. In the latter, Frederick Place, a terrace of large three storey houses erected in 1834 on the site of the gardens belonging to Gloucester Lodge, the King's summer residence. In the early years of the last century, the horse-drawn vehicles and then the charabancs would use the space in front of the statue for parking. The island on which the statue now stands was created in 1956 for the smoother flow of traffic and is now laid to lawn and gardens. It was in 1949 that the statue was first painted and it has recently been given a major restoration.

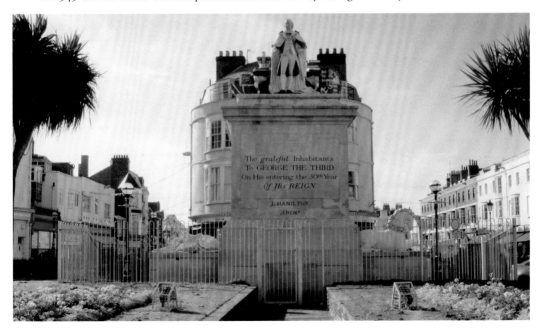

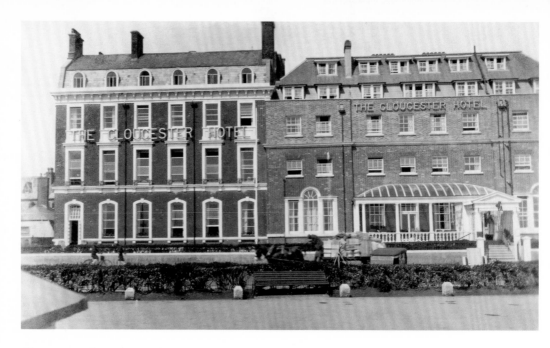

Gloucester Lodge, otherwise known as Royal Lodge, was built about 1780 for the Duke of Gloucester, brother of King George III. The King stayed at Gloucester Lodge during his early visits from 1789 and in 1801 purchased the property from his brother. The building was sold in 1820, the same year as the death of the King and again in 1859 when it became the Gloucester Hotel under Mr Luce who also ran the Royal Hotel next door. In the following decade a large extension was added at the south end and a new entrance door created at the front. In 1927 the hotel suffered a fire which caused considerable damage. During restorations, another floor was added and the hotel reopened in 1929. It finally closed in 1985 and was converted to apartments in 1989.

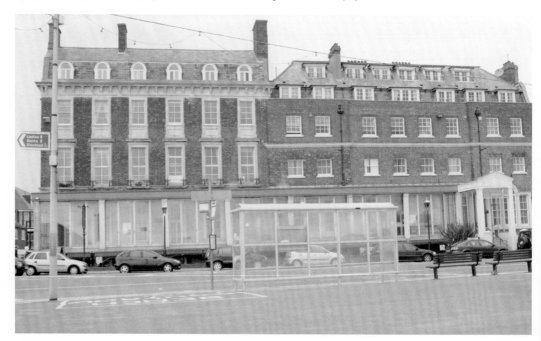

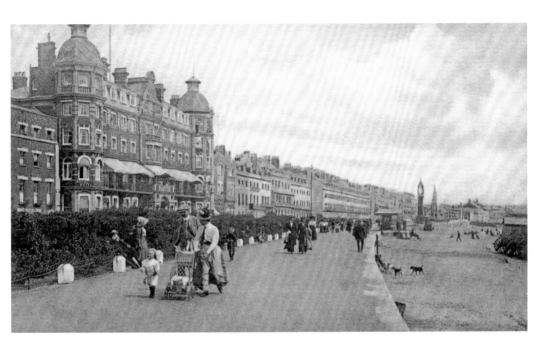

The original Royal Hotel had been built around 1773 in Gloucester Row and was formerly known as Stacies after its first proprietor. After the building of Gloucester Lodge next door in 1780, the hotel changed its name to Royal. With its large bow fronted windows and columned porch, it was decided by the Corporation that it was out of date and so demolition took place in 1891. For many years there remained a gap where it had stood, until the new Royal Hotel was completed in May 1899. Along with this development was the Royal Arcade, once a covered parade of shops, followed by the remainder of Gloucester Row, the last one having been demolished. These were built around the 1780s and include balcony railings added in about 1820.

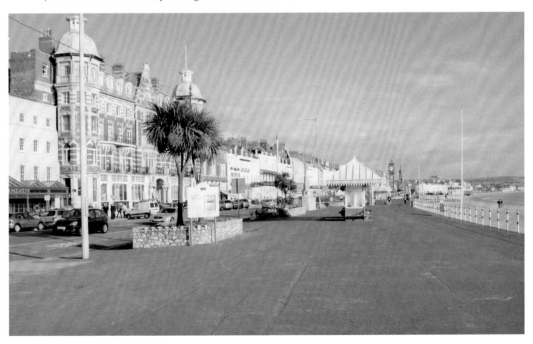

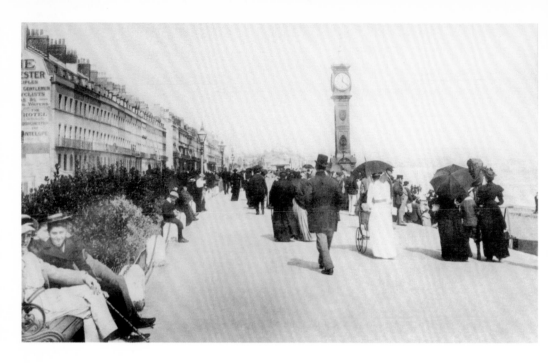

The junction by the clock of King Street with the Esplanade begins with Royal Crescent, planned as a long row of 49 houses in a crescent shape, building of which began about 1795 and was completed around 1805 with just 15 of the original plan built. Crescent Street was built behind it and at the end, a small side road leading to it. The Esplanade at this point, like much of the rest, was extended seawards in order that the road could be widened and the clock today stands immediately to the side of the road. The next terrace, Belvidere, took much longer to complete, begun in 1818 but not completed until 1850.

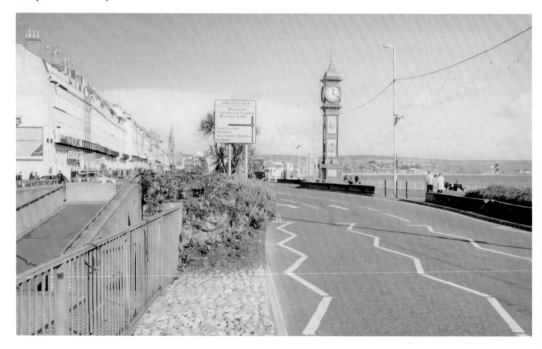

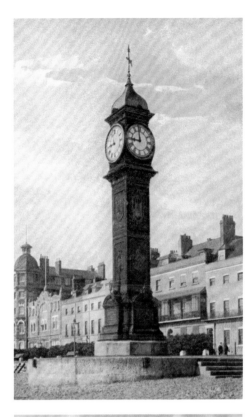

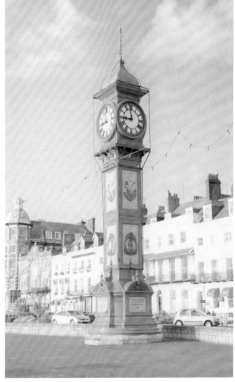

The Jubilee Clock is probably Weymouth's most well-known landmark, standing almost central in this part of the Esplanade and at the top of King Street. The clock tower was built to commemorate Queen Victoria's Golden Jubilee in 1887 and was unveiled the following year. The 44 foot tower, bearing portraits of the Queen and the coat of arms of the borough was paid for by public subscription and the handsome clock with an illuminated dial the gift of Sir Henry Edwards, former MP for Melcombe Regis and great benefactor to the town. It was erected on the beach on a stone plinth with steps leading up to it, has never been moved, but the Esplanade built up and extended around it in the 1920s and about the same time the clock was painted in its bright colours.

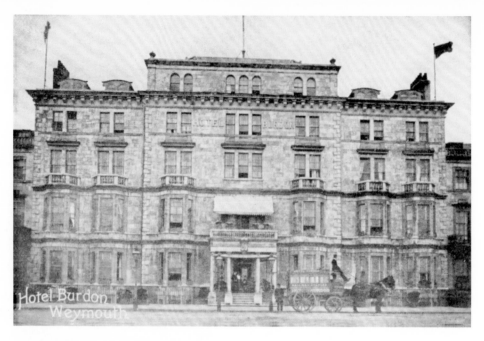

During the Great Gale of 1824 when the Esplanade was destroyed, two boys were drowned at the 'Narrows', the point where the Esplanade was only a short distance from the Backwater. In the 1830s, much of the Backwater was infilled and the reclaimed land was later built on at what became known as the Park District. Victoria Terrace was built around 1855 and its central feature, the Hotel Burdon (also known as the Imperial Burdon Hotel) was built on the site of the 'Narrows'. The *Southern Times* claimed that it was named after William Wharton Burdon, the owner of the Gasworks, a close associate of the hotel's builder, Philip Dodson. Wrangles with the authorities over the plans delayed building and it was 1858 before the hotel opened. During the war it was used as a military hospital and in 1971 after a change of ownership, it was renamed the Prince Regent.

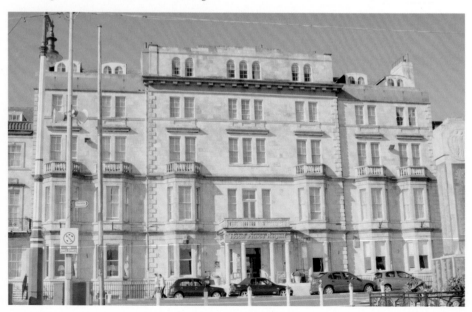

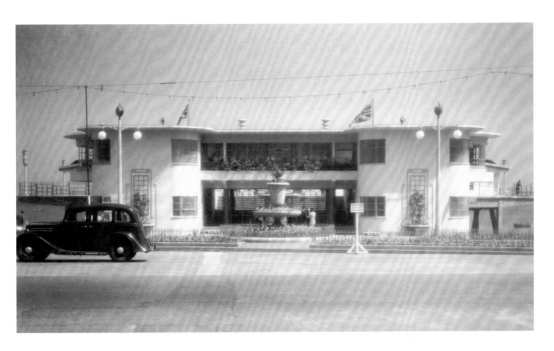

The Pier Bandstand was erected in 1939 with a short pier at the back extended into the sea. It replaced makeshift bandstands of canvas which were erected at this point during the summer season, but after less than fifty years, the pier was deemed unsafe and was blown up by controlled explosion in 1986. The front part, the bandstand area, which was used for various entertainments including beauty contests, remains though much extended on either side during the 1950s and 1960s and renovated in the 1990s. The rounded ends on either side were partly enclosed by the extensions. The central ornamental fountain flower bed remains, as do the ornate lamps on either side, although altered. On the Esplanade to the front, there are several white stones, said to be the originals that once lined the entire Esplanade with chains linking them.

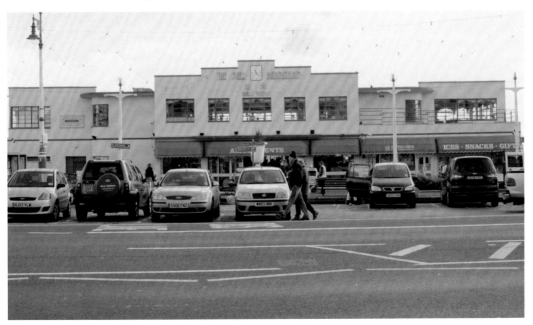

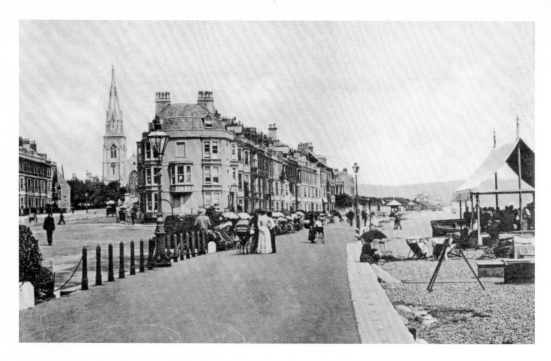

The terrace of twelve houses of Waterloo Place was built in 1835 in similar style to Pulteney and Devonshire buildings at the other end of the Esplanade. It was here at number six that the first incumbent of St. John's, the Rev. John Stephenson lived whilst awaiting the building of the vicarage of 1859 next to the church. Near the end of the Esplanade, the rounded end of Brunswick Terrace matches those by the King's Statue. The Esplanade was extended seawards here too and the Pier Bandstand replaced the temporary shelters that had been used before. The war memorial in Portland stone was dedicated on 6 November 1921 and in 1932 the names were put onto bronze plaques. More were added in 1997 with the names of those killed in World War 2.

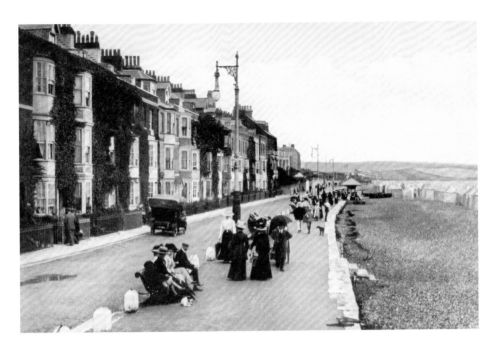

Originally known as Brunswick Buildings until the name was changed in 1880, the building of Brunswick Terrace began about 1822 but wasn't completed until five years later. Possibly the Great Gale of 1824 halted work for a while and these houses being closer to the sea and exposed were a more risky undertaking. Following the terrace, the grand houses of Greenhill include the former Somerset House built around 1840 that became the Greenhill Hotel and was the home of Henry Pickard-Cambridge, a nephew of John Trenchard Trenchard, owner of Greenhill House that became the Grand Hotel. During the period 1850-1875, the latter was a barrister and Deputy Lord Lieutenant of Dorset as well as a wealthy landowner, having inherited the Poxwell estate from his Great Uncle, John Trenchard whose surname he took as a condition of inheritance.

St. John's Church was built on land purchased from the Johnstone estate, designed by Talbot Bury and built of Ridgeway Hill stone by Philip Dodson. It was consecrated by Bishop Hamilton on 19 October 1854 with the Rev. John Stephenson its first vicar who was to remain in the incumbency for 50 years until his death in 1905. At the time it was built, it lay within the boundaries of the ancient parish of Radipole, as did Greenhill, but in an ecclesiastical reorganisation of 1856 it became part of Melcombe Regis being assigned its own district. The vicarage beside the church was completed in 1859 and in 1864 St. John's school, designed by Crickmay, was built on the corner of Dorchester Road with William Street. The school was demolished after closure in 1974 and St. John's Court now stands on the site. This is followed by St. John's Terrace (3-35 Dorchester Road).

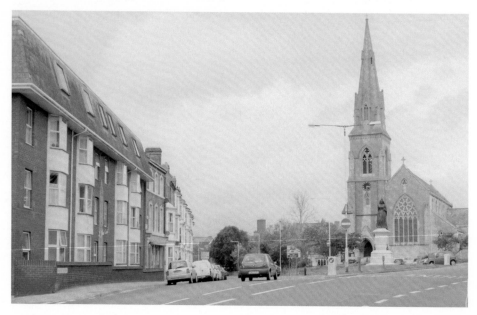

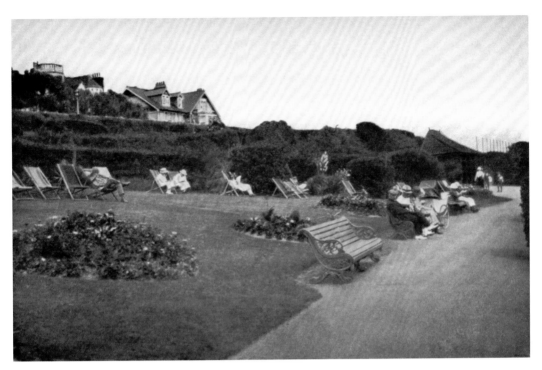

Greenhill has something of a grisly past for in 1582 the rector of Radipole, James Marwell in recording the bounds of the parish, describes it as 'where ye pyrate was hanged' and in 1685 it was the site for the displaying of the gruesome remains of a Monmouth Rebel, condemned by Judge Jefferies at his Bloody Assizes. Greenhill Gardens were created in 1872 on land owned by Sir Frederic Johnstone and in 1902 he gave them to the borough with the stipulation that they be kept and maintained for the benefit of the public as ornamental and recreational grounds. Vilat Hackfath Bennett, who owned a large drapery business and was also Mayor 1918-19, gave an 'Armistice' Shelter which still stands in the gardens today.

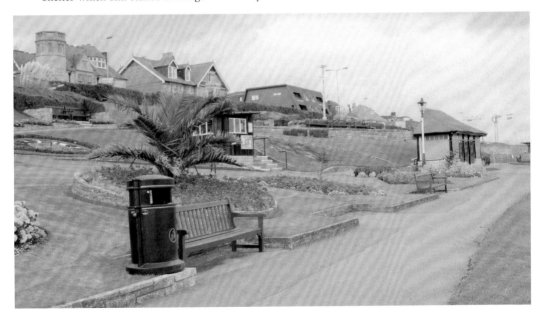

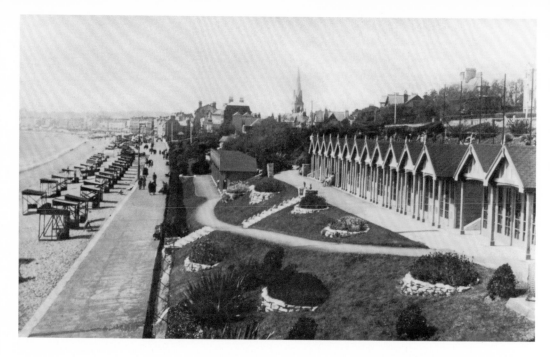

The layout of Greenhill Gardens has changed over the years and the tennis courts are now in a different area to what they were up to about the 1940s. Adjacent to the main gardens the chalets were built by the Corporation in 1923 below the tennis courts as 'bathing bungalows' which could be let for long or short periods, to be used as 'dressing-rooms and sitting-rooms'. The tennis courts were later moved and their previous location is now a continuation of the main gardens.

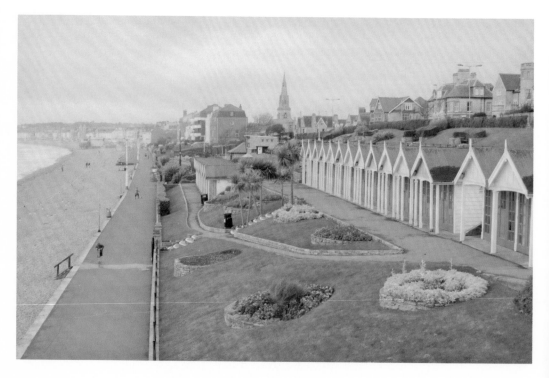

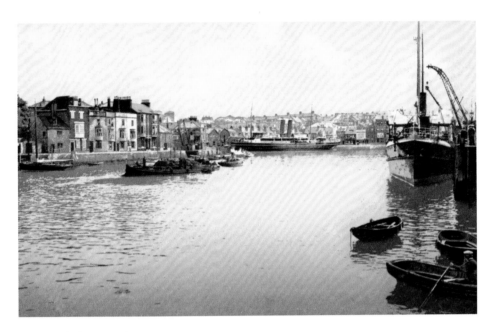

Around the Harbour

On the Weymouth side of the harbour at what was known as Hope Quay but is now Nothe Parade, the lifeboat station has been established at Weymouth since 1869 when a boathouse and slipway were built and the '*Agnes Harriet*' came into service. In 1921 the boathouse was adapted ready for a motor lifeboat, the '*Samuel Oakes*' came into service in 1924. In 1996 a new boathouse and slipway were built. The lifeboat, the '*Ernest and Mabel*' has been in service since 2002. Further up, 'The Hole' was an inlet at Hope Cove that was filled in by the local inhabitants in 1781 and later, in 1889, Hope Cove was widened by the demolition of houses that backed on to it from Hope Street to enable berthing of the larger GWR ships. The area around here is now known as Hope Square where Brewers Quay, a converted brewery, is the main feature and houses a shopping village, the Timewalk and Weymouth Museum.

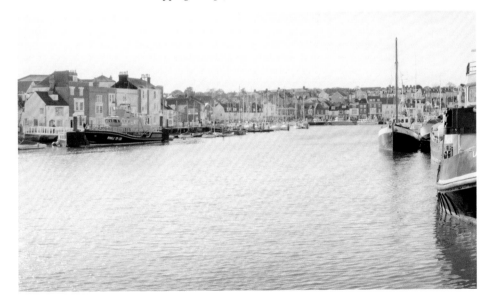

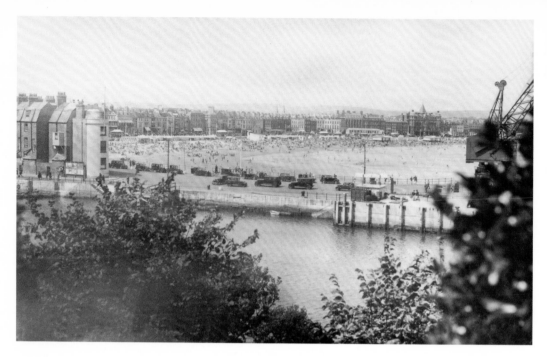

On the Melcombe side of the harbour, a cargo stage was built by the rear of Devonshire Buildings in 1877 and was used primarily for the unloading of potatoes, tomatoes and flowers from the Channel Islands. The cargo stage was reconstructed in the early 1950s and the harbour wall brought into line to run continuously to the ferry terminal. From the vantage point on the Nothe, it's easy to see the wide sweep of the sands beyond the harbour and before 1980 when demolition took place, the twin spires of Gloucester Street Congregational Church and prior to 1957, the tower of Christchurch in King Street.

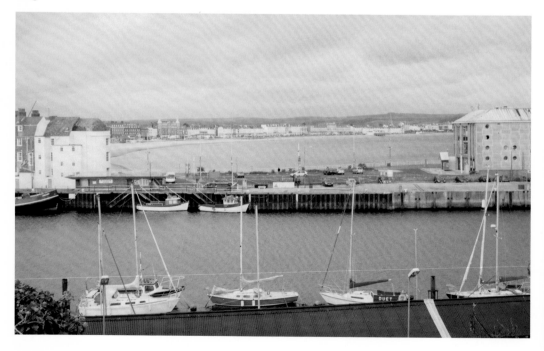

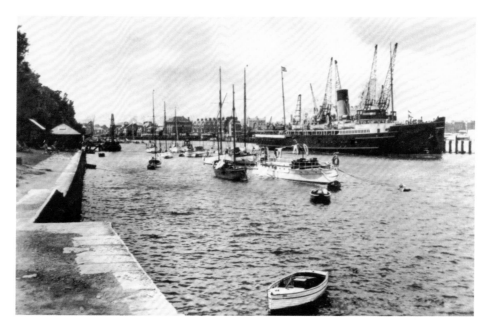

Besides the Channel Island's steamers running out of Weymouth, there were also the Paddle Steamers run by Cosens and Co. The company began with the PS Rose in 1848 running excursions to Lyme Regis and Southampton. Through the years their vessels were involved with salvage and rescue operations and ferrying supplies to the breakwaters as they were being built and later to the Navy. In the summer season, visitors could enjoy excursions to Portland Harbour, Lulworth Cove, Swanage and elsewhere. In 1962 Cosens moved their head office from Custom House Quay to the inner harbour and Commercial Road where they also had a ship repair and engineering business. The Paddle Steamers ceased to operate in 1967, but the company continued and in 1987 moved to Portland. The company was sold during the 1990s. Their site at the inner harbour was named Cosens Quay in 2006 to commemorate their long association with Weymouth.

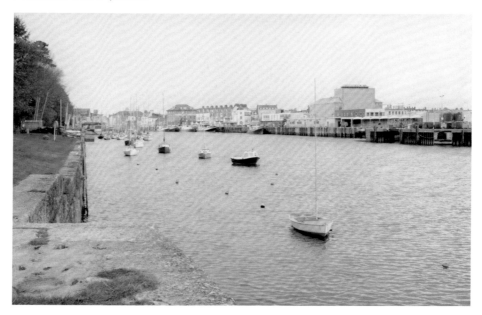

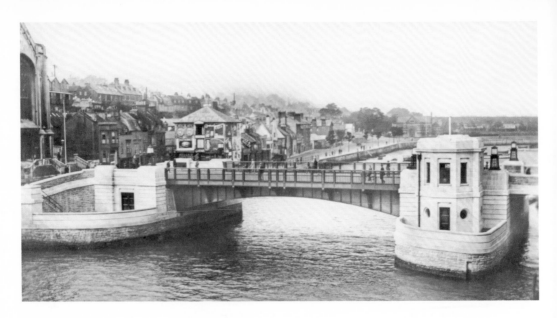

Although the twin boroughs of Weymouth and Melcombe Regis were united by Queen Elizabeth I in 1571, no bridge was built between the two until 1597 when a wooden 17 arched draw-bridge was constructed. Several more bridges followed and in 1770 another bridge was built, but this time its location was further up the harbour at the end of St. Nicholas Street on the Melcombe side. In 1824, a swing bridge, the first built of stone, was built back in the original position at the end of St. Thomas Street. On 4 July 1930, the present Town Bridge, with a hydraulically operated central opening, was officially opened by the Duke of York (later to become George VI). A party from Weymouth, Massachusetts attended the opening ceremony having presented an inscribed granite slab built into the bridge. The view up from the bridge has changed dramatically with the demolition of most of the old High Street, North Quay and the Sidney Hall, as well as Chapelhay destroyed by bombs during the war.

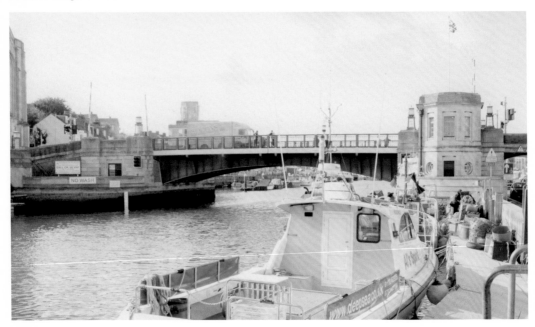

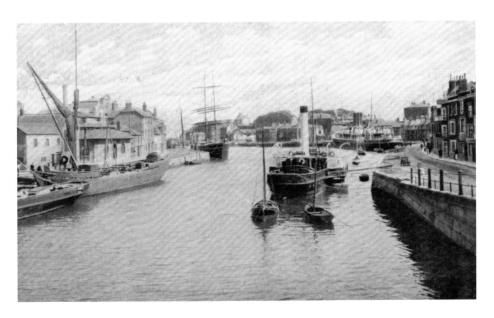

Melcombe Regis was the port where the plague, known as the Black Death, entered England in 1348. At Custom House Quay on this side, the Ship Inn that stands on the corner of Maiden Street, dates back to the seventeenth century. It was extended onto the quay after the demolition of the large red warehouse. The Fish Market of 1855 was designed by Talbot Bury, as was the Market House in St. Mary Street of the same year, but was only used for a short time because of the contamination by coal being unloaded on the quayside. After being used for storage, it came back to its proper use in 1988. The original George Inn was owned by Sir Samuel Mico, who in 1665 bequeathed it in his will to the Corporation, the profits thereof to be used to apprentice three poor children. The Mico charity continues to this day. On the Weymouth side, Trinity Street, once part of the old High Street, was where Ralph Allen had his summer residence at number 2 from 1750 and is credited with having started the holiday trade before the visits of George III.

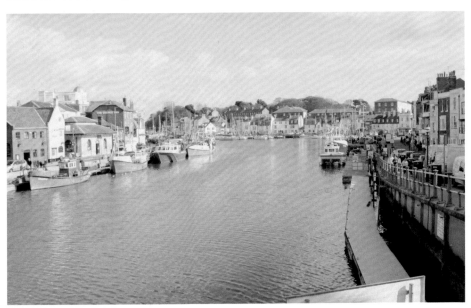

The Nothe Walk, alongside the harbour below the Nothe Gardens and Fort, is the present day Nothe Parade. It followed on from what was originally called Hope Quay and it was then known as the Ballast Quay or Wharf running up as far as the Stone Pier. Part way along this part of the quayside there are some steps leading up to the Nothe which have railway lines looking like handrails, but they were in fact a short line for running ammunition and supplies up to the Nothe Fort after being landed at the quay immediately below where there was a small jetty especially for it. The little jetty was removed in the 1930s.

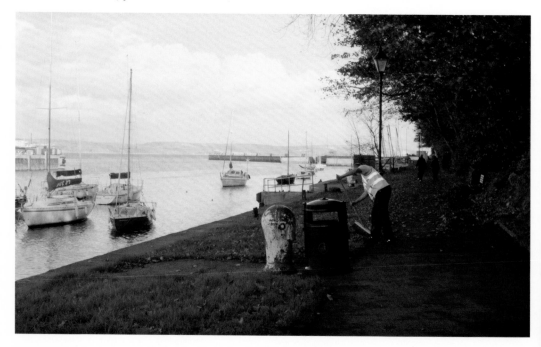

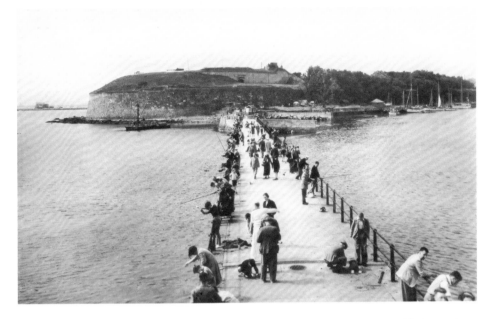

The Stone Pier was first constructed in the eighteenth century, with extensions added over the years. During the Great Gale of 1824, it was severely damaged and had to be rebuilt. Sir Henry Edwards provided financial assistance for a 250 foot extension to the pier in 1876 and this was built to provide further protection to the harbour. In the First World War the pier was extended again and at the same time, the round structure at the end of it with a spiral staircase was built to take a navigational light. Further damage was caused to the pier and after some particularly bad storms the pier had to have major reconstruction works carried out in the 1980s. In 2005 a memorial was erected on the pier to those who lost their lives in the sinking of the Earl of Abergavenny in Weymouth Bay two hundred years before. The Nothe Fort above the pier was built during the 1860s, although this was always a place of fortifications during times of war and was in use during the Civil War of the 1640s.

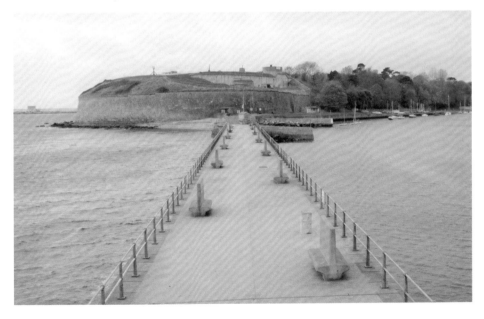

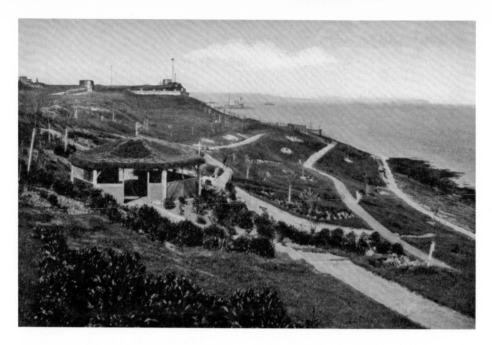

The Nothe Gardens, up above the harbour, were created in 1888 although some walks had already been created in the 1870s. The walkways commemorate Royal occasions, such as Jubilee Walk at the bottom to mark Queen Victoria's Golden Jubilee in 1887. The first bandstand was a thatched roof construction and in 1924 it was replaced by one which had previously been in the Alexandra Gardens on the other side of the harbour, where a new concert hall had been erected in its place. The bandstand in the Nothe Gardens was removed in 1964. Elizabethan Way commemorates Queen Elizabeth's Silver Jubilee of 1977. Landslips over the years have caused parts of the gardens to slip into the sea and one of 1988 destroyed a pillbox from World War II.

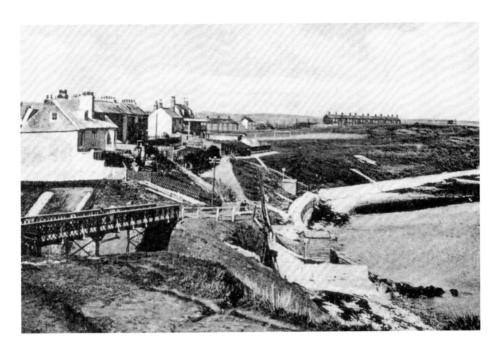

The Great Western Railway Company put forward proposals for a small port to be constructed at Newton's Cove in the 1890s. Some construction took place and a public house built, the Railway Dock Hotel, opened in 1902, but the scheme was abandoned in 1913. The remnants of it included a wooden bridge over Newton's Road, otherwise known as Dock Road, which was replaced in 1934 by the present one made of concrete. At one time an old bathing hut stood at the Nothe end of the bridge and was said to be the original one used by George III. The pub was demolished in 1989. In 2003, major work took place on the sea defences around the Nothe and Newton's Cove and has been made very attractive.

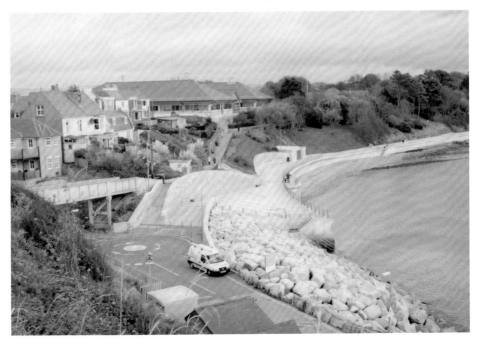

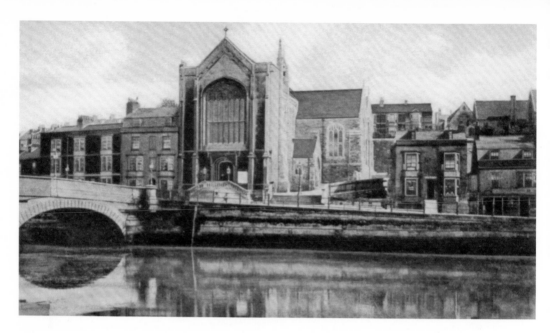

Until 1836 the inhabitants of the old town of Weymouth had to travel a mile to the parish church at Wyke Regis. The rector there, Rev. George Chamberlaine, recognised the need for them to have their own place of worship, and so, in 1834 the foundation stone for Holy Trinity was laid, the church being paid for by the rector himself. The church, at the end of the old Town Bridge, was designed by Philip Wyatt, complete with crypt below accessed via the passage beneath the steps, and was consecrated in 1836. In the late 1880s, under Crickmay, the church was extended and the interior reorganised. Holy Trinity school had been built in 1853 up above at Chapelhay, on the site of the St. Nicholas chapel that had been destroyed during the Civil War of the 1640s. Remnants of pier stones discovered on the site having belonged to the chapel were incorporated within the school building. The school was severely damaged during World War II and was demolished.

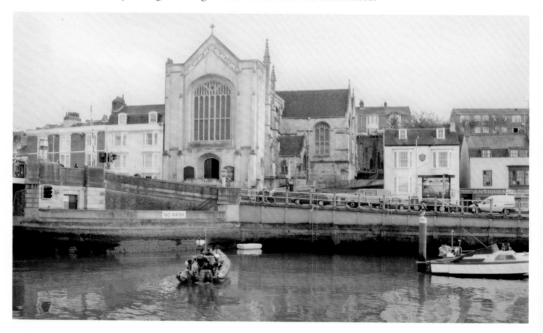

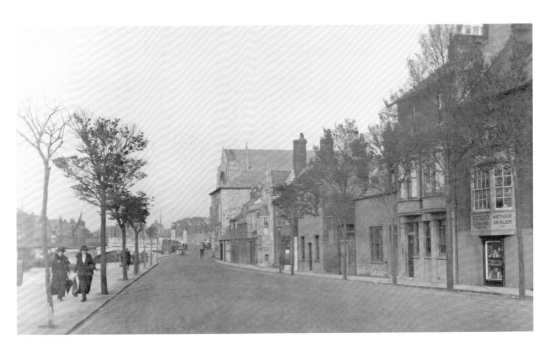

The old buildings of North Quay included houses and shops, such as Mrs Amelia Stroud's antique shop at no.9 in 1911 and a Tudor house at no.4 which is believed to have been a former harbourmaster's house for its lookout tower on its east side, as well as having been the Queen's Arms Inn at some time. The Weymouth Civic Society fought a long and hard battle with the council to preserve this house, which was being run as a hotel, but to no avail and it was demolished in 1961. Timbers from the staircase were rescued from the demolition fire and used for communion rails in Radipole church. After such wanton destruction of our heritage, the present day council offices were built on the site and opened in 1971.

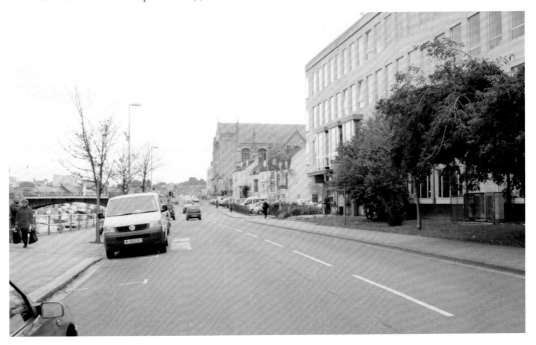

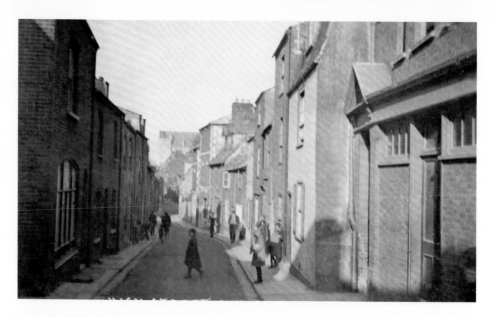

The present Kingdom Hall, part of the old High Street is one of the few survivors of the demolition spree of the 1960s. It began as the Good Templars Hall built in 1875, on a site that had previously been occupied by a building of Tudor origin and opened the following year. In May 1879 having been converted, the building opened as a Coffee Tavern, promoted by the Temperance movement, sobriety being its aim. During the early years of the last century the front of the building underwent changes in design and is now quite different, though recognisable today. It has been the Kingdom Hall since 1978. Opposite is the Boot Inn which has survived from the seventeenth century, but most of the remainder of the old High Street is now the car park of the council offices. However, a close inspection of the walls of the car park reveals some clues as to its use in former times.

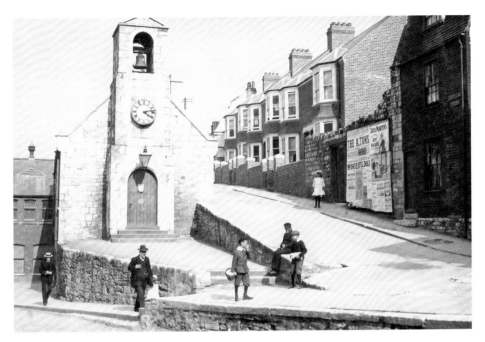

The Old Town Hall, part of the original High Street of old Weymouth was rebuilt in 1774, although some of the stonework is thought to survive from earlier times. The bell turret of seventeenth century origin once contained a bell dated 1633 and thought to have originally come from Radipole church. In former times, it was here that the council business was dealt with along with that of the local magistrates. Hereabouts in 1645 the rages of the Battle of Weymouth took place during the Civil War and many men were mercilessly slain, including Francis Sydenham, the brother of the Governor, Colonel William Sydenham. To the side of the Town Hall, Chapelhay Street led up to the Chapel Fort and was for a time after the wars, known as Francis Street, perhaps in commemoration of the valiant soldier. The Old Town Hall was heavily restored in 1896, but today stands sadly neglected, a vital piece of our heritage going to ruin.

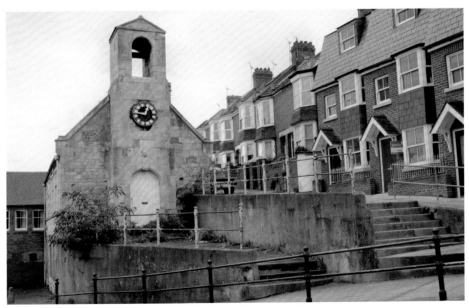

High West Street was once part of the High Street and this too, being close to the Old Town Hall, was very much involved during the battles of the Civil War. The building on the corner with Love Lane was the High West Street Tavern run by William Board during the 1870s to the 1890s and then by his son Joel. On the opposite side of the road, just below the wall, was the Town Pump that supplied the area with water. The pump was moved in 1990 and now stands outside the Old Rooms Inn in Hope Square. The houses date mainly from around the eighteenth and nineteenth centuries and beyond are the houses of Chickerell Road, once known as Town Lane.

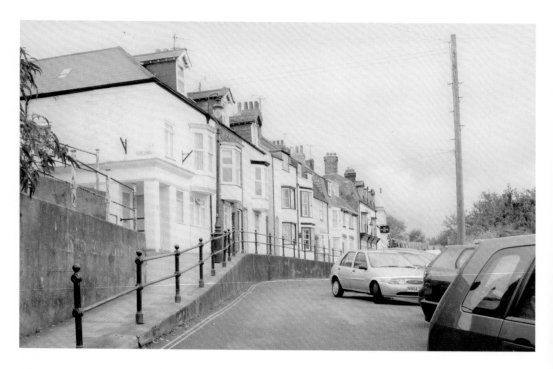

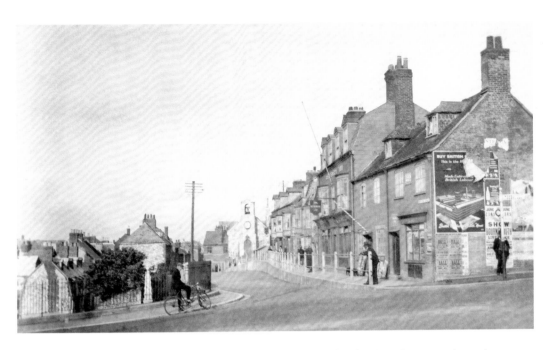

The other end of High West Street from Boot Hill suggests that the Town Pump was located near the corner of the road, so maybe there were once two. The little rows of houses of Silver Street and Jockey Row lay on the north side running parallel and below the houses that once stood on that side of High West Street. They were demolished in the 1930s under a slum clearance order and the Fire Station now stands on the site having been built in 1939. The house on the other corner was once a grocer's shop and the Belvedere Inn was in the tenure of John Wells for the last twenty years of the nineteenth century. It is still in use today.

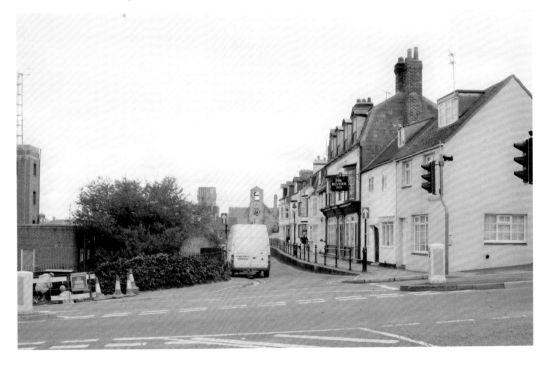

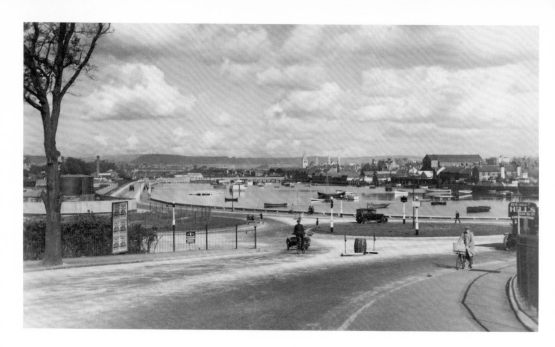

The Gasworks were built near the bottom of Boot Hill at the junction of Newstead Road with what is now Westwey Road, in 1836 by William Wharton Burdon who supplied gas to the town until 1866 when they were taken over and then in 1948 were nationalised. They closed in 1962 and were demolished, except for two of the gasometers, one of which remains today. The site is now government offices. The Sunnybank Power Station began supplying electricity in 1904, but closed in 1966 and the buildings along with the tall chimney were demolished in 1974. Westwey Road was opened in 1932 having been built on land reclaimed from the Backwater. The inner harbour is now a marina.

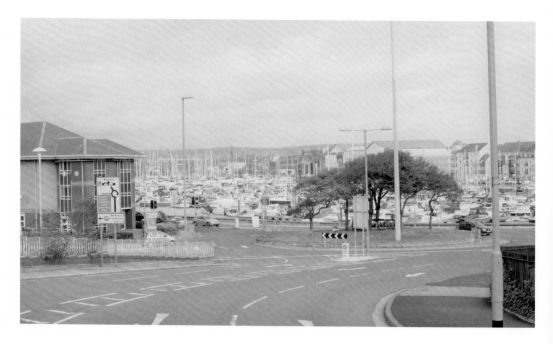

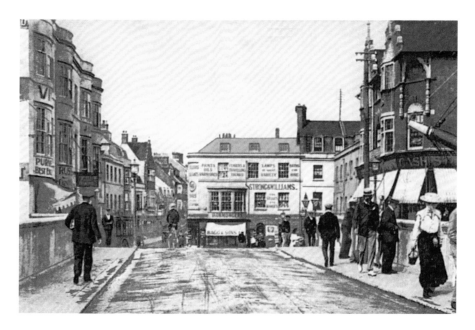

Around and About Town

The entrance into town from the old Town Bridge into St. Edmund Street and St. Thomas Street is still easily recognisable today, despite the changes that have taken place. Bridge Buildings, three-storey shops on the corner of Lower St. Edmund Street with the bridge, were built just after a new Town Bridge was built in 1824. They were demolished in 1928. The Crown Hotel replaced a previous building of the same name on the same site during Victoria's reign, but had always been a place for merchants to meet and carry out their business. The Golden Lion just around the corner in St. Edmund Street was another trading post and hostelry dating back to 1721 and mentioned in early guide books as one of the best places to stay. The buildings on the other corner of the bridge are much the same today with the one closest now being the Rendezvous nightclub, previously the Palladium cinema.

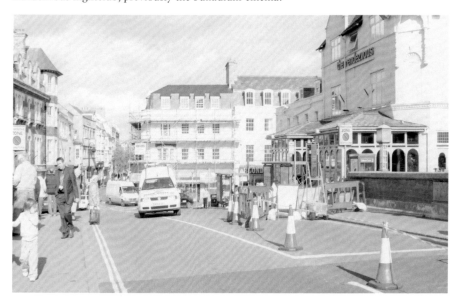

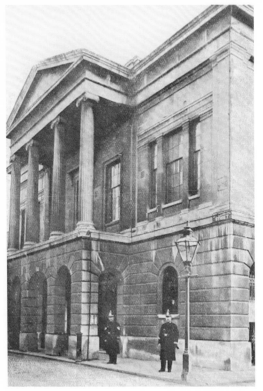

The Guildhall in St. Edmund Street was built of Portland stone and opened in June 1838. It replaced an earlier building that had survived from 1618 that had been known as Melcombe Town Hall, where the business of the council was carried out and the magistrates held court. The area in front of it was the original Town market where all local produce was to be sold under a bye-law from the seventeenth century, to enable the Town Council to levy a tax for the upkeep of the town. The Guildhall was also the Police Station for over a hundred years until a new building was provided for them on the Dorchester Road in 1955. The council still carry out their meetings at the Guildhall today and it is also the district registry office.

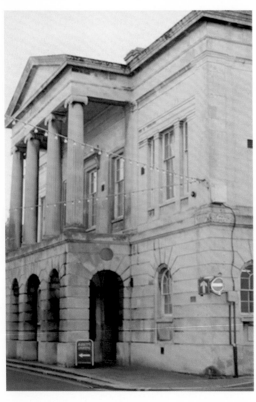

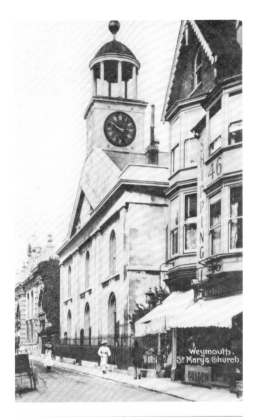

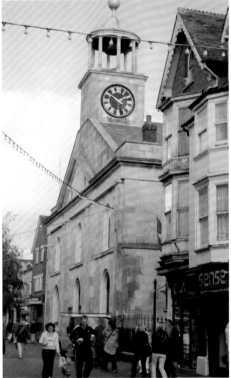

St. Mary's Church of 1817, designed by James
Hamilton, replaced a church built in 1606 when
Melcombe Regis became the mother church to
Radipole, reversing their previous roles. Inside
there is a painting of 'The Last Supper' by Sir
James Thornhill (1675-1734) who was born in
the town and was an MP for the borough. He is
known for the eight paintings which adorn the
interior dome of St. Paul's Cathedral in London.
Sir Christopher Wren (1632-1723) who designed
St. Paul's after the Great Fire of London was also
an MP for Melcombe Regis. The ornate Market
House next to it was built in 1855, designed by
Talbot Bury and demolished in 1939. The building
on the corner of Church Passage replaced a Tudor
house demolished in 1883 that had once been the
home of John Pitt, Mayor of Weymouth.

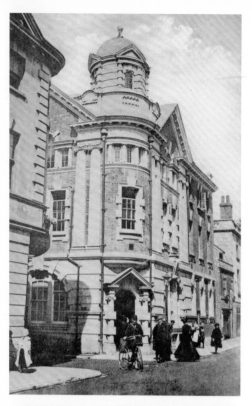

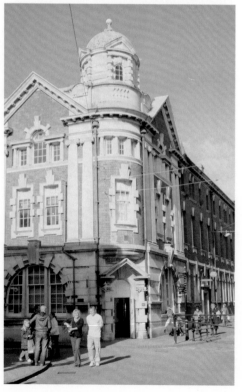

The General Post Office in St. Thomas Street formerly occupied buildings further along the road, but in 1907 a new Post Office was built on the corner with Lower St. Alban Street. The main building was extended in the early 1920s after the demolition of two adjacent buildings. The Post Office stands on the site of several houses that had included a Manor House as shown on a map of 1774. On the opposite corner, there stood the office, store and off-licence of the John Groves brewery. Next to that was the Old Bank of Eliot, Pearce & Co which had been established in the late eighteenth century but failed in 1897, causing much financial distress around the town and beyond. Both buildings were demolished in 1966 when the present Tesco store was built.

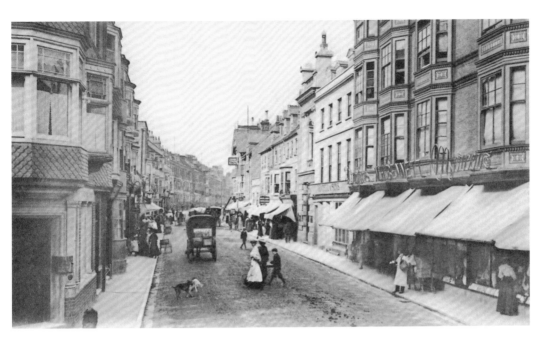

St. Thomas Street, one of the main streets in the town centre, has changed little in a hundred years, except for the demolition of a row of shops where New Look now stands on the corner with New Bond Street. The Old Rectory next to it, but set back from the street and dating from the late 18th century was revealed when the shops in front of it were demolished in the 1980s, although high fencing then surrounded the site until 1999 when it had been fully restored. At that time it was called the Old Rectory still, but has since become Barracuda. It was built as two houses (81 & 82), in which during the 1870s the curate of St. Mary's, Thomas Falkner lived at 82 with his son, John Meade Falkner who wrote the famous novel, 'Moonfleet'. Crickmay the architect lived at 81. Opposite, on the corner with Bond Street, V H Bennett had his large drapery store which is now W H Smith.

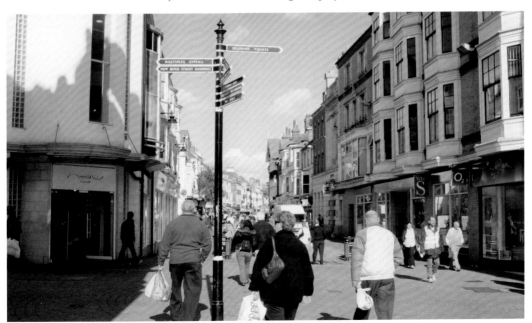

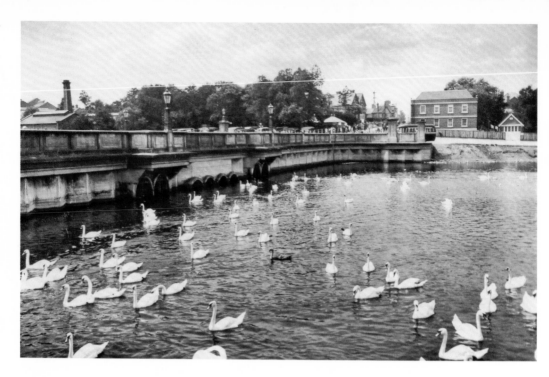

The construction of the new Westham Bridge began in 1920 after reclamation of land on both sides of the Backwater. It was to replace an earlier wooden bridge which had served its purpose since 1859 in providing direct access across to Westham and the Melcombe Regis Cemetery. The British Construction Company of Westminster having gained the contract for the building of it in 1920, the new bridge was opened with much ceremony on 13 July 1921 by the then Mayor, Councillor R A Bolt. A commemorative plaque was unveiled at the end of the bridge by Colonel J R P Gooden, then chairman of Dorset County Council. Traffic continued to use the bridge up until the 1980s when the new road bridge was built further up, at which time Westham Bridge was closed and is now a car park.

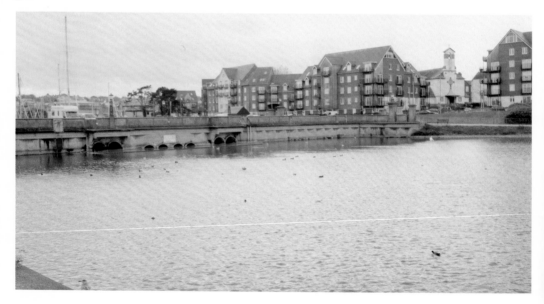

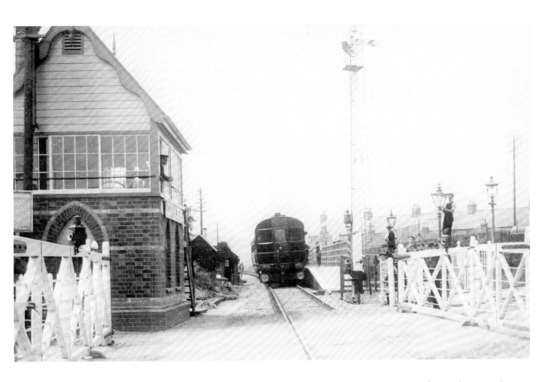

The Weymouth to Portland railway opened in 1865 with its route going across the Backwater via a wooden bridge and then across Abbotsbury Road at Littlefields. When the Whitehead's Torpedo factory opened at Ferrybridge, many of its employees came from Westham and with Westham's continued development and rising population there came the need for a station. A new girder bridge was constructed across the Backwater in 1909 to replace the old wooden one and in July the same year Westham Halt was opened to passengers. In March 1952, Westham Halt was closed to passengers and in 1965 the railway ceased to operate. The Halt was demolished in the 1980s, except for the platforms which remain today and it is now part of the Rodwell Trail following the old railway lines to Wyke Regis.

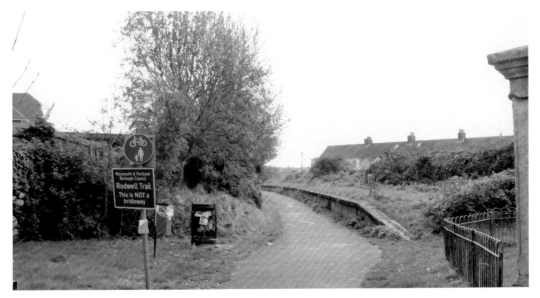

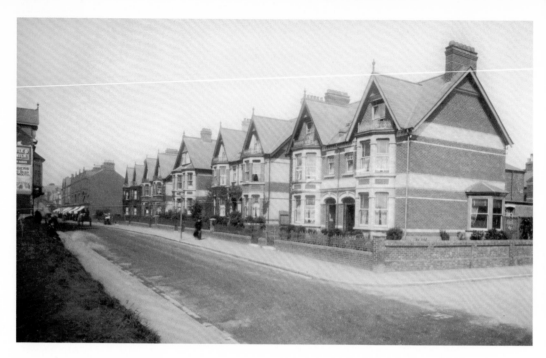

The Littlefields area of Westham was developed mainly by John Bagg, a local builder who leased the land from the Earl of Ilchester in 1888 and subsequently bought it. This part of Abbotsbury Road was later in development than most, with houses this end being built in 1891 and given names such as 'Hazeldene' (no.16), the only one to retain its name today. Walter Dovey, a well known local photographer of his time lived at what is now no.10. Most of the parade of shops opposite was not built until circa 1901. Westham Bakery on the corner with Ilchester Road was the first to be built in 1898 and was in operation by the time of the 1901 census when Ernest Phillips was the baker. The shop is now the premises of Active Mobility.

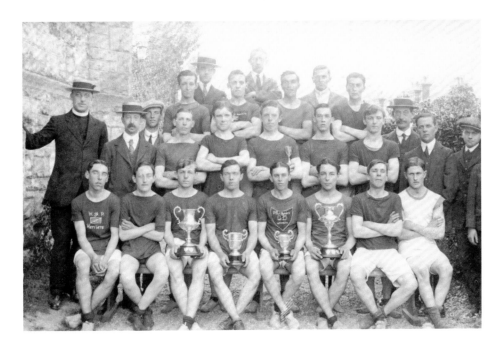

The Westham St. Paul's Harriers were founded around the turn of the last century from the St. Paul's church boys' club by Canon Martin Fisher. Athletics had been a popular sport in the Weymouth area for some years prior to this and it is possible that the Harriers had been established before, especially since Mr H A Hurdle had presented them with a silver cup in 1904 to be awarded to the winner of the 10 mile race that was held annually. The Harriers were renamed in 1929, the Weymouth St. Paul's Harriers, and apart from a temporary break during the war years, they have continued to this day under that name. Times change though and there are now two groups of Harriers, adult and junior and both now allow women and girls to join.

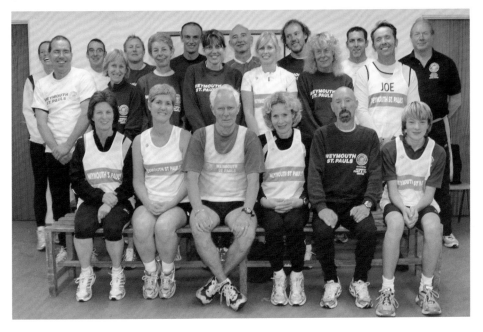

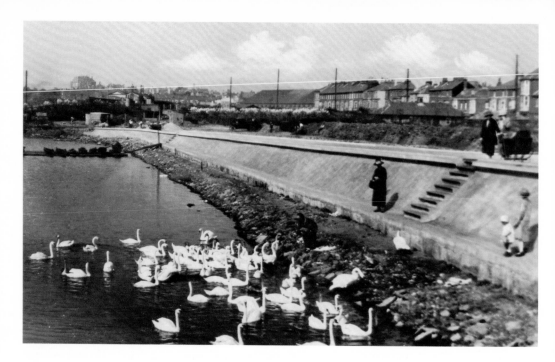

The embankment of Radipole Lake, otherwise known as the Backwater, was constructed as part of the reclamation of land required for the building of the new Westham Bridge in 1921. Until then, the water at this point was tidal right up to the top of the lake at Radipole, but the new bridge was built with sluices, effectively damming the lake and rendering it no longer tidal. On the reclaimed land behind the embankment, tennis courts and later, the ground of the Melcombe Regis Bowling Club were constructed. Further on, the Melcombe Regis Gardens with an archway walk over which roses grew. Later, a crazy golf course occupied the site of part of the present-day car park.

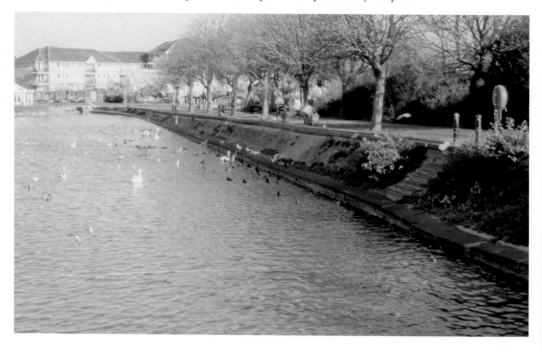

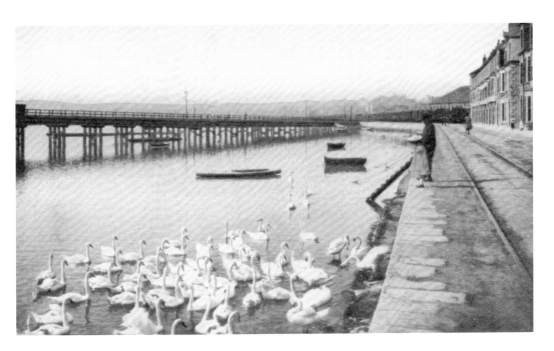

The railway lines in Commercial Road ran alongside the lake until the early 1920s when much land was reclaimed. Passing over the end of King Street, they run alongside the former Portland Railway Hotel and Alexandra Terrace where the bus station was opened in 1922, and down to the harbour. The Weymouth to Portland Railway opened in 1865 and was taken across the Backwater by a viaduct. It was on the land now occupied by Swannery Court that Melcombe Regis station once stood, all traces of it having now disappeared. The Portland railway closed in 1965 and in the late 1970s the viaduct was dismantled. The new road bridge was opened in 1986, close to the original line of the railway and the roundabout put in at the same time.

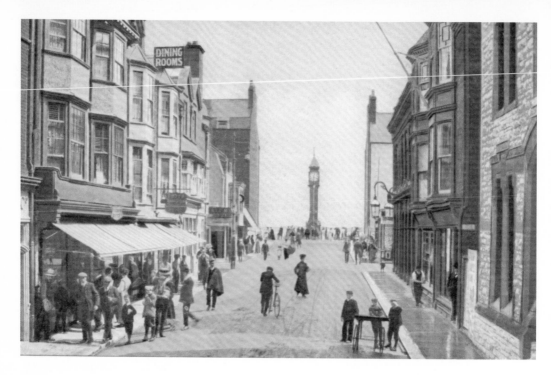

When the railway came to Weymouth in 1857, King Street was the area that visitors arriving by train would see first. At the eastern end of King Street towards the Jubilee Clock, at its junction with Crescent Street hotels such as the Sun and the Half Moon run by Solomon Sly, who by 1861 was running the recently rebuilt Fountain Hotel across the road, would cater for their needs. Tett's tea and dining rooms were also in this part of the street, along with other shops. The Eye Infirmary on the other side of the road moved there in 1872, having previously been located first in Bond Street and then St. Mary Street. The British Legion moved into the building in 1947 after their premises on Westwey Road were destroyed by an enemy bomb in 1941.

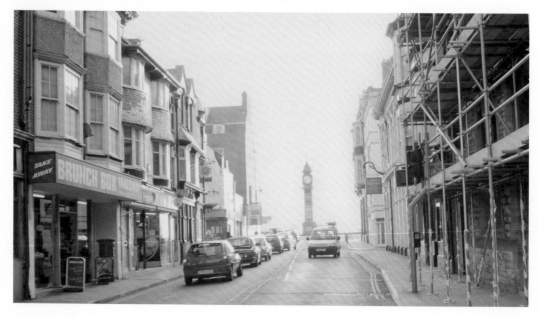

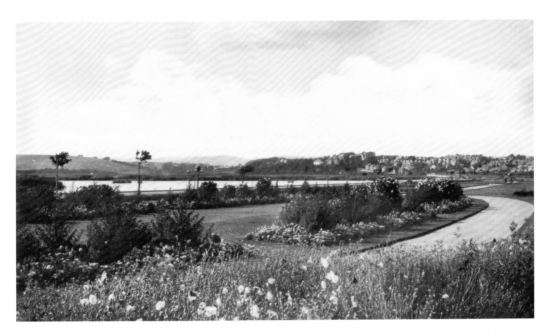

In 1925 land was reclaimed from the Backwater beyond Westham Bridge and the railway viaduct, at what is now known as Radipole Park Drive. Before long the New Melcombe Regis Gardens had been laid out and planted, with splendid views across the lake to the then undeveloped area of Southill and the Spa Road area of Radipole. The landscaping included tennis courts and later a park for children. The gardens became known as Radipole Park Gardens and in 1999 were renamed the Princess Diana Memorial Gardens, though they are still commonly known by their previous name. They are laid out in much the same way as they were when they were first created, but the views across the lake are limited, being mostly screened by trees.

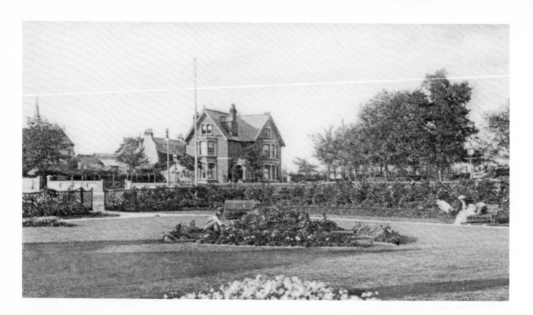

St. John's Gardens were laid out with lawn, shrubs and flower beds and opened on 20 July 1904 on land given by Sir Frederic Johnstone whose Weymouth home was across the Dorchester Road at what at one time was confusingly known as Radipole House, despite there being another house further up the road by the same name. Likewise, the farm on which it was situated was called Radipole Farm, as was the farm of the Manor in Radipole Lane in the village. The farm on Dorchester Road later became known as Wadsworth's and then Nangle's after the estate managers running it. The farmhouse still exists today as part of the old college residential development.

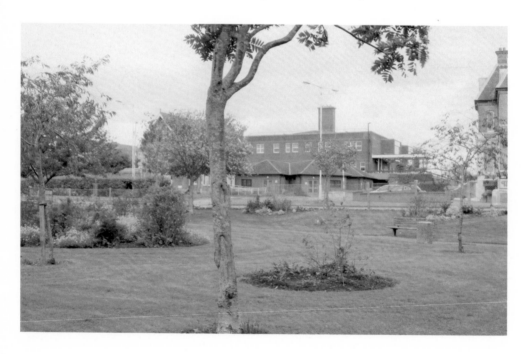

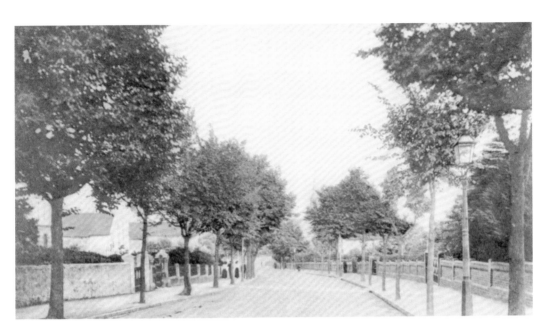

The lower end of the Dorchester Road was dominated by the tall buildings of Weymouth College and the spire of St. John's. At the time the college was built there was not much else in that part of the road, except for the farm buildings and the original Park Hotel that stood almost opposite the farm. An estate map of 1802 shows that the farm had only recently been built and that the Park Hotel started out as a warehouse. The college buildings remain and have been converted to housing. Much of the boundary walls are still the same. That immediately before the college belongs to what was once called Talavera Villas.

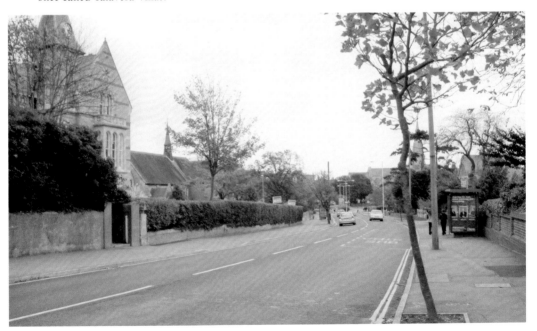

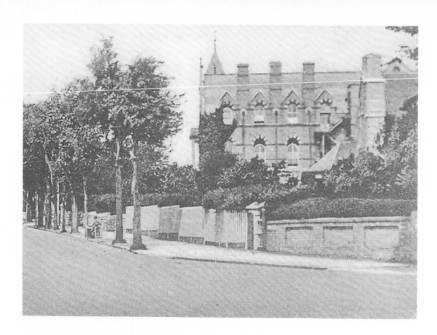

The building of Weymouth College on the Dorchester Road was completed in 1865 having been designed by Crickmay, a local architect. The first headmaster was the Rev. John Ellis who had already been appointed in 1862 when the school was about to open the following year as the Weymouth Grammar School in Commercial Road. Two years after opening at the Dorchester Road site, the name was changed to Weymouth Collegiate School. Ellis continued to be headmaster until 1879 when the Rev. C R Gilbert took over until the end of 1884. The original boundary of the college lay along the eastern side of the main building where it was marked by a wall. In 1891 a new building was erected to the eastern side of the wall and in 1895 the College Chapel was built further over still. The old buildings of the college have now been converted to residential use.

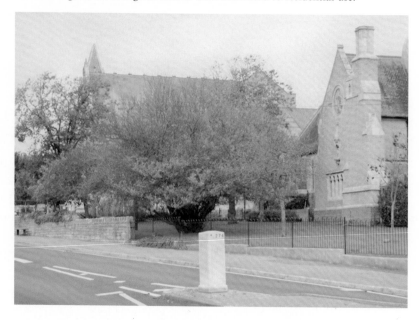

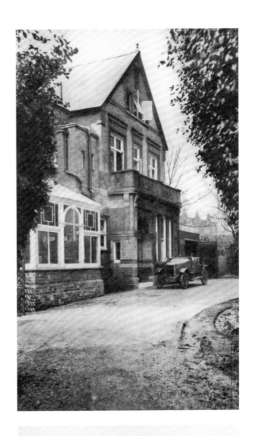

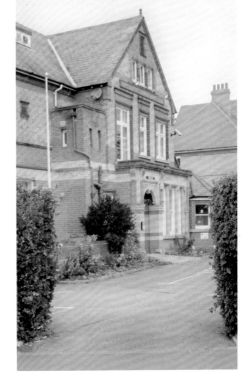

The College House, known originally as Lindisfarne was possibly built about 1888 and was said to have been built on the site of the original Park Hotel. This is not the same as the current Park Hotel on the corner of Grange Road. The college house stands on the corner of Dorchester Road with Carlton Road and for many years was the home of the headmaster of the college until about 1930 when it became the Linden Hall Hotel. In a 1938 Weymouth guide, the hotel was then run by Mrs E Dean. Linden Hall is now the premises of the Weymouth Conservative Club.

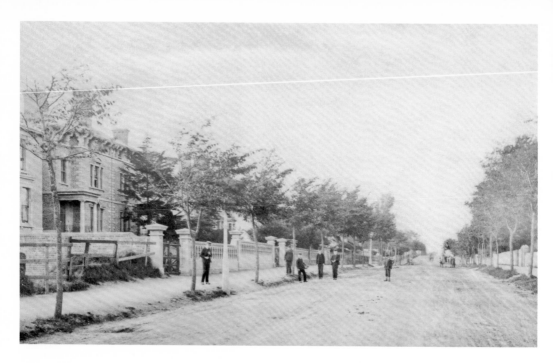

The view looking up the Dorchester Road towards Lodmoor Hill has changed remarkably little in a hundred years or so. No.55 Dorchester Road is now the Acropolis Hotel having been built during the 1870s and then known as Mount Radford. No.57, Cambridge Villa, built by 1871, was one of the few to retain its original name and was a guest house in the 1930s-1950s. No.59, Montrose Villa; no.61, Fairfield, and no.63, Runnymeade, were all built by 1871. No.65, Treverbyn, built some time later in the 1870s, retained its name until very recently and is now the George Hotel. Across the road, part of Wellington Terrace, built around 1835 became the Hotel Rembrandt at 12-18 Dorchester Road and Wellington House was the Windsor Hotel in the 1930s, but is now the Shirley Hotel.

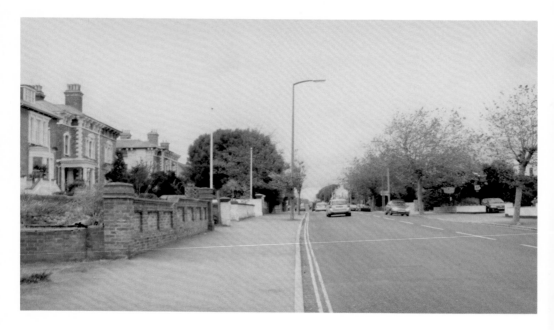

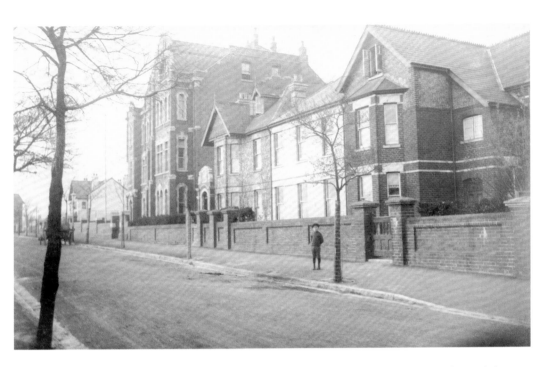

The Convent of the Sacred Hearts in Carlton Road North opened in 1910 as a boarding and day school. Four years later with the outbreak of the First World War, the Convent was used as a Red Cross Hospital and at some point afterwards a new wing was added to the already existing building. Various other buildings in the locality were also used to accommodate the growing number of pupils later on, but in 1992 the Convent schools closed and were converted to housing. Further housing was built on the site of the school hockey field opposite.

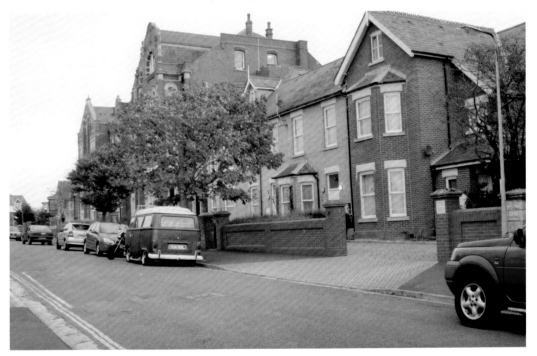

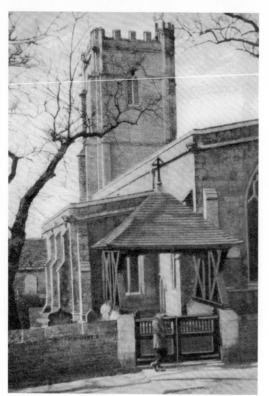

Wyke Regis

The parish church of All Saints, Wyke Regis was consecrated in 1455, although it is known that an earlier church existed in 1172. As well as serving Wyke, the church served the inhabitants of Old Weymouth until 1836 when Holy Trinity was opened by the harbour. Its close proximity to the treacherous Chesil Beach has seen it serve many victims of shipwrecks whose bodies have been thrown upon the shore. Many of the victims of the East Indiaman, *The Earl of Abergavenny*, that foundered after striking the Shambles bank off Portland in 1805 and sank several hours later in Weymouth Bay, lie buried in a mass grave in the churchyard. Its Captain, John Wordsworth, brother of the poet, William Wordsworth, lies here too. Another mass grave contains the bodies of 140 who lost their lives with the sinking of the Alexander in 1815 and another, the victims of three of the six ships of Admiral Christian's fleet wrecked in one night in 1795.

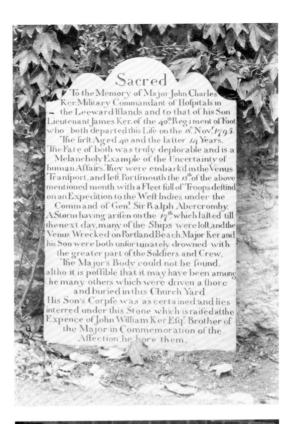

A gravestone survives in the churchyard in memory of Major John Charles Ker, Military Commandant of Hospitals in the Leeward Islands, aged 40 and his 14 year old son, Lieutenant James Ker of the 40th Regiment of Foot. Both were drowned on the *Venus*, one of the ships to be wrecked on the night of 18 November 1795. The *Venus*, the *Piedmont* and the *Catharine* all part of Admiral Christian's fleet bound for the West Indies, foundered together being thrown upon the Chesil bank near Fleet in horrendous storms. The gravestone records that the body of the Major was never recovered and that his brother, John William Ker, paid for the stone to be erected. Leaning and hardly legible now, it stands in front of the wall where several other stones were put after they were removed from the main part of the churchyard in front of the church.

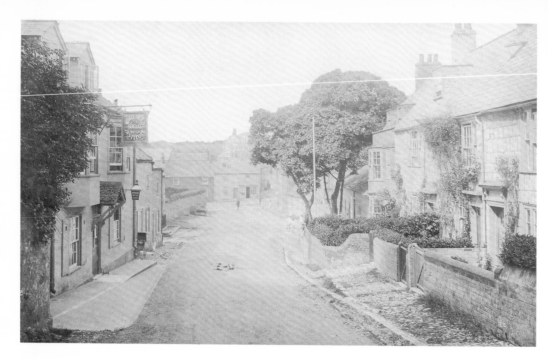

The 'Square' in Wyke is the area around the centre of Chamberlaine Road, which was named after Rev. George Chamberlaine, the incumbent of Wyke from 1808-1837 who was also responsible for the building of Holy Trinity Church. Some of the earliest buildings around the Square date from the early 18th century. The present social club was formerly the White Hart Inn before changing its name to the New Inn in 1851. It became the Whitehead's Social Institute (working man's club) from at least 1908 and from 1948 the Wyke Regis Social Club. The horse trough a little further on into the Square is at the bottom of the steep All Saints Road and it is said that nobody is a true 'Wykeite' until they have been in it! The large wall beyond enclosed the grounds of the former Wyke House Hotel, built in 1805 and demolished in 1974 and the area has since been redeveloped into housing.

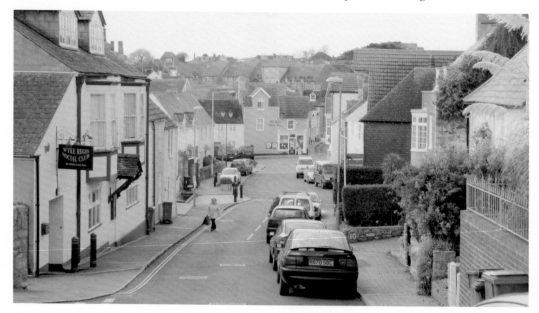

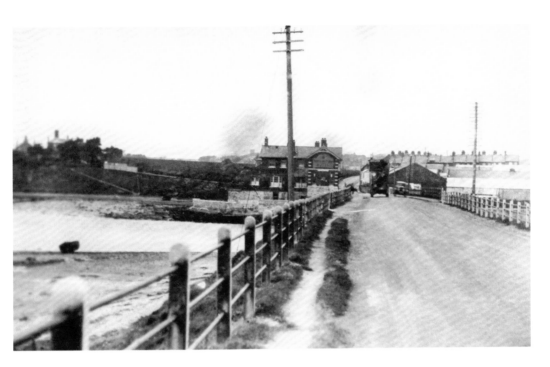

Ferry Bridge or Ferrybridge is so called as this is where a ferry operated until a road bridge was constructed to enable easier access between the mainland and Portland. There stood a Passage House and the ferry was operated by means of ropes and the power of a horse to cross the water from Wyke to the bank of sand that led to Portland. After the great gales of 1824 in which the ferryman lost his life and the Passage House was destroyed, an act was passed to enable the building of a bridge. The first bridge was completed in 1839. In 1865 the railway line to Portland opened running from the east and then alongside the bridge and in 1896 a new, steel bridge was built that lasted until 1985 when it was replaced. The Royal Victoria Inn, now called the Ferrybridge, was built around the turn of the last century and stands almost opposite the site of the former Whitehead's Torpedo works.

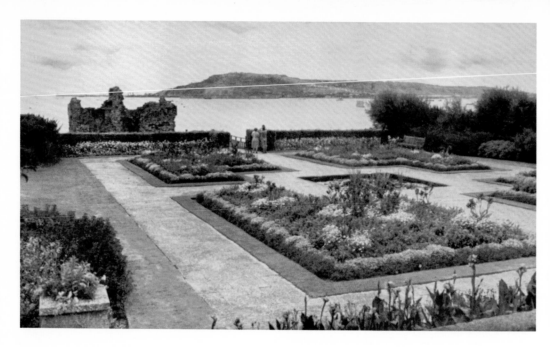

Sandsfoot Castle Gardens were laid out in 1931 as the Tudor Gardens, reminiscent of those at Hampton Court Palace, the home of Henry VIII who built Sandsfoot Castle. A central fishpond was created with a fountain in the middle and a wooden bridge constructed over the moat and leading to the castle. Around the 1920s the Tea Lawn pavilion was built just to the west side of the castle and at that time tennis courts were on the site of the gardens costing 2 shillings per court per hour to play. Later, the castle was fenced off by railings to prevent climbing on the perilous ruins. A concrete shelter was built in 1964 on the other side of the gardens.

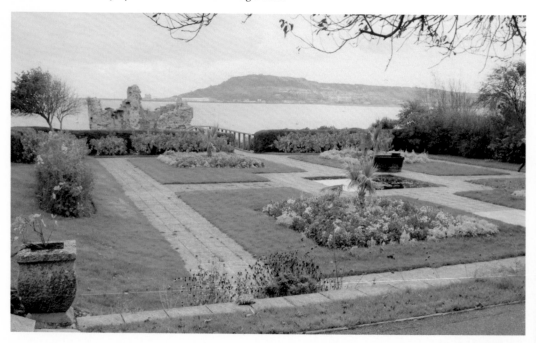

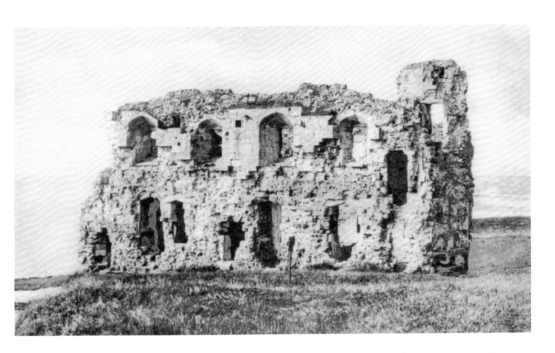

Sandsfoot Castle was built in 1539 by Henry VIII as part of his coastal defences against invasion from the Catholic countries of Spain and France after he changed the established religion from Catholic to Church of England, in order that he could divorce Catherine of Aragon. With it came the Dissolution of the Monasteries and some of the stone from Bindon Abbey near Wool, was used in the building of Sandsfoot. Portland Castle across the water was built just prior to Sandsfoot and the two castles were to act together in protection of this part of the coast. During the English Civil War, Colonel Ashburnham was governor for the King and surrendered the castle to the parliamentary forces in 1644. The castle was used as a mint and manned by the Wyke Regis Militia.

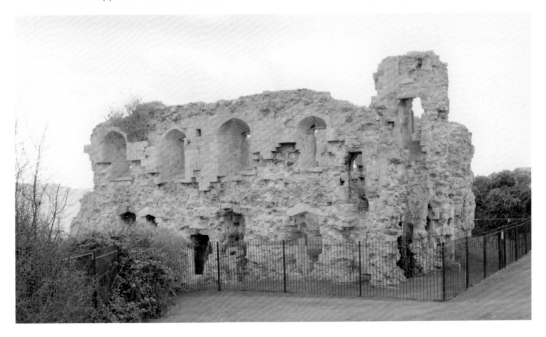

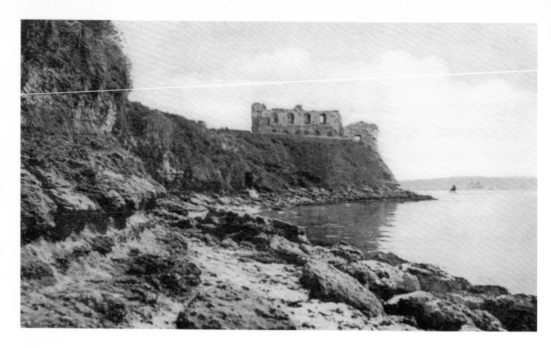

From the time of the Civil War, Sandsfoot Castle remained in the hands of the government under its governor, Humphrey Weld. Coastal erosion became so great that it undermined the cliff and Humphrey Weld left the castle in 1665 whereupon it slowly began to crumble into the sea below. The building of the breakwater in 1849 to enclose Portland Harbour, offered some protection from the tides, but not enough for the soft clay soil on which the castle stands. Part of the cliff face shows the foundations as the castle stands precariously on the cliff edge. Over the years much of it has fallen, a large amount in 1952, and many remnant rocks lie scattered on the beach below.

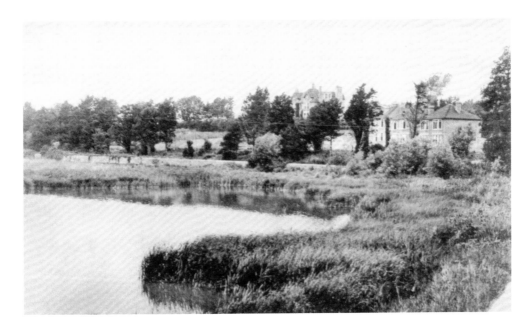

Radipole

The view over Radipole Lake has changed much in little over a hundred years. Until the 1890s the only building in this area was the Spa. The land until then belonged to Radipole Manor but Richard Ffolliot Eliot, at one time an eminent banker, found his bank in financial difficulties and before long was plunged into bankruptcy. Just prior to that happening he made the decision to sell off some of the land in plots. Abbotts Court, a large mansion, was built in 1895 by John Bagg, a local builder and three times Mayor of Weymouth. He too went bankrupt in 1910 and Abbots Court was purchased by Thomas Burberry, the founder of the Burberry Company. The house was demolished in 1987 and two large blocks of flats overlooking Radipole Lake now stand on the same site, but retain the name of Abbots Court.

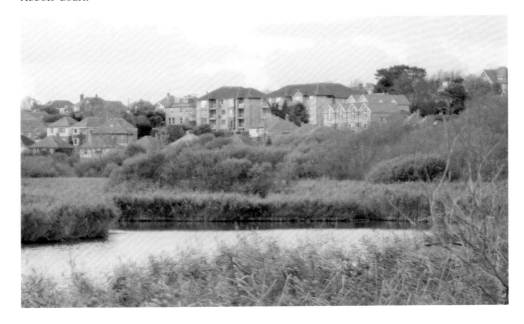

Spa Road takes its name from the Spa that was on the site of the present Jubilee Court until the late nineteenth Century. The sulphur spring was discovered in 1830 in a field belonging to John Henning but farmed by the Gill family. Soon after, a pump room and Spa House were erected and the business was run by the Gills for around fifty years. Several Spa buildings are shown on a plan of the area when plots belonging to Radipole Manor were sold off in 1890. By 1905 a steam laundry had been built on the site to serve this side of Weymouth, but in 1910 it caught fire and was left an empty shell. It was rebuilt and continued in operation until its closure in 1976. The houses along Spa Road on the southern side were mainly built soon after the purchase of their plots in 1890. Those on the northern side were built later.

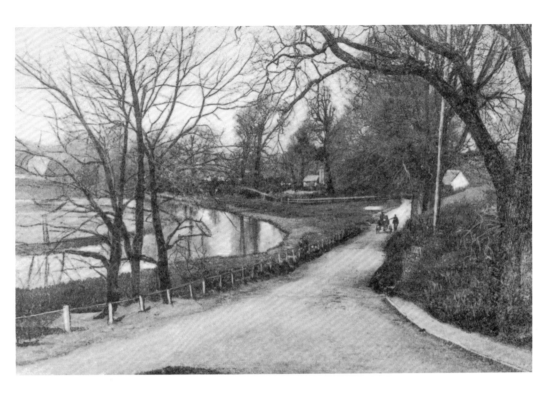

The northern end of Radipole Lake is believed to have been a Roman port long before that of either Weymouth or Melcombe Regis and indeed many Roman artefacts have been discovered in the area with a burial site found at the top of the hill in the vicinity of Southill Primary School. This end of the lake was tidal, having its own small beach, until the building of Westham Bridge in 1921 effectively dammed the lake. A medieval settlement is known to exist beneath 'Humpty Dumpty Field' across the road from the lake and in the mid 1980s when the lane was being widened by taking a strip off the field, a medieval oven was discovered along the line that a new wall would take.

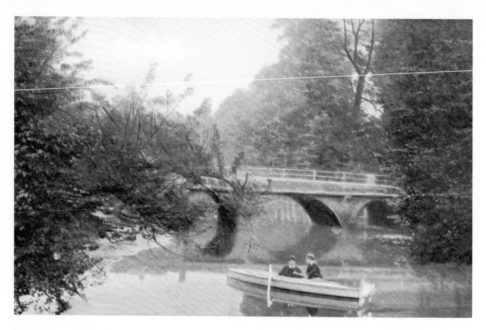

The quaint old bridge over the River Wey was originally constructed over a ford *c*.1820, probably by the Balston family of Corfe Hill. In the early years of the last century, pleasure boats could be hired from the lower end of the lake and rowed upstream for visitors to enjoy the quaint beauty of the village with a stop for refreshments at the Honest Man Inn on Radipole Lane. The bridge suffered severe damage during a storm in July 1955 which saw much of the Wey Valley under water. Myrtle Cottages which stood close by were so badly damaged by the floodwater that they eventually had to be demolished while Alma Place, although under several feet of water survived to remain today. Letterbox Cottage dating from around the time of the Civil War still survives today too standing just the other side of the bridge.

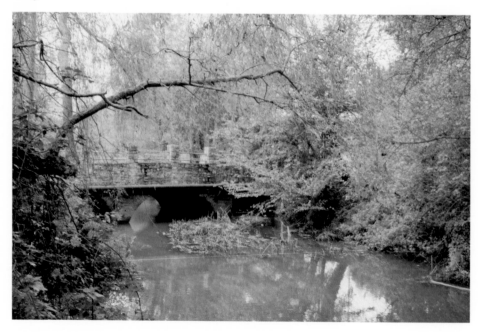

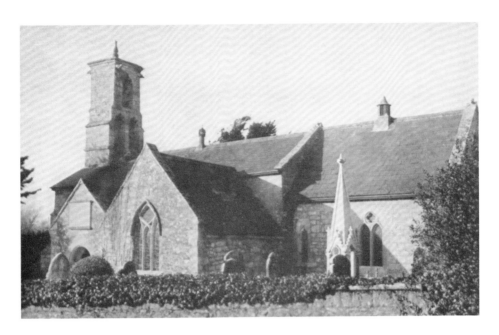

St. Ann's church, lying very close to the Elizabethan Manor House, is possibly Weymouth's oldest building, having been built circa 1250. The nave dates from this time as does the font and additions were made during the fourteenth century when some rebuilding took place. Further rebuilding took place during the eighteenth century, including the south chapel. St. Ann's was formerly called St. Mary's and was originally the mother church to Melcombe Regis when the church there was called Christchurch. In 1605 when a new church was built at Melcombe, their roles were reversed, much to the consternation of the then rector, James Marwell, who fiercely opposed such a move. In 1927 the church at Radipole became a parish church once more and was officially rededicated to St. Ann. Several victims of the wrecking of the *Earl of Abergavenny* which sank in Weymouth Bay in 1805 lie buried in the churchyard.

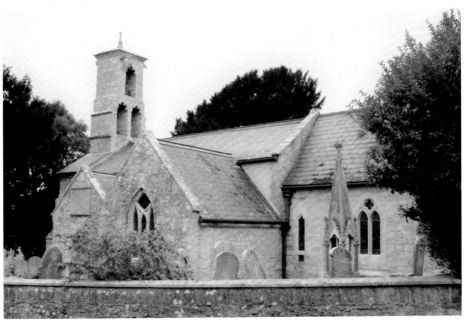

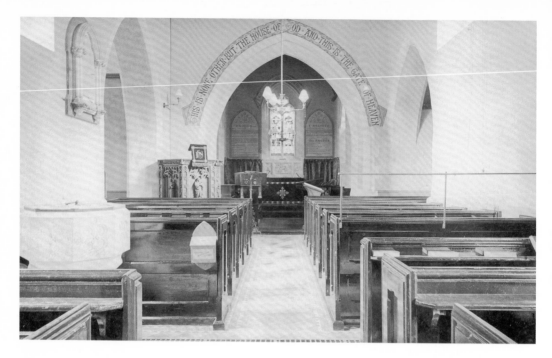

The interior of St. Ann's church has changed little, except for the painting of the woodwork. The ancient altar is now alongside the path before entering the church and a font is located in the garden to the north. The gallery is Victorian having replaced one from the Elizabethan period. The communion rails were created out of the staircase timbers of no.4 North Quay during its demolition and are of sixteenth century date. The windows in the north chapel survive from the fourteenth century and in the south wall of the chancel there is a small priest's door that led into the Manor House next door. The south chapel contains several memorials to the landowning families of Balston of Corfe Hill, Steward and Gordon-Steward of Nottington House which lay within the bounds of the parish.

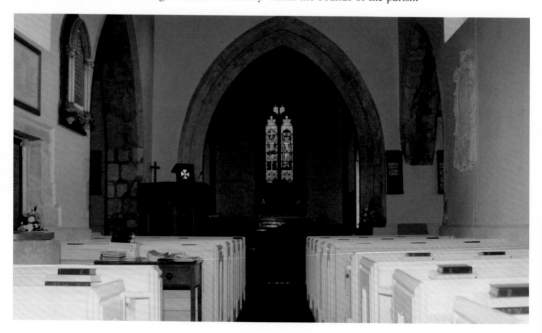

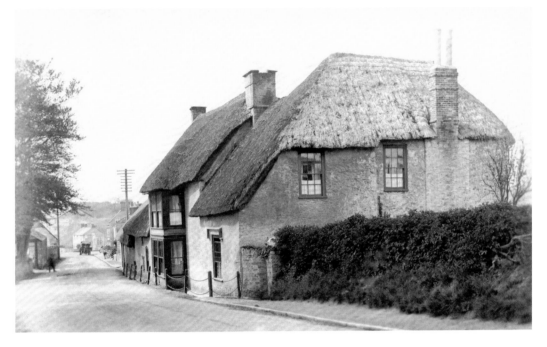

Broadwey and Upwey

Broadwey Farm and its accompanying barn on the Dorchester Road dates from around the mid to late seventeenth century, once thatched, it ceased to be a working farm in the 1950s and underwent restoration. An Elizabethan panel of a lady, found in the 1950s at the former Grammar School that became the Arts Centre in Weymouth, was incorporated within the restoration of the barn. Close by, the first few houses in Mill Street were once a dairy and across the road from there stands the Victorian school, now converted to housing.

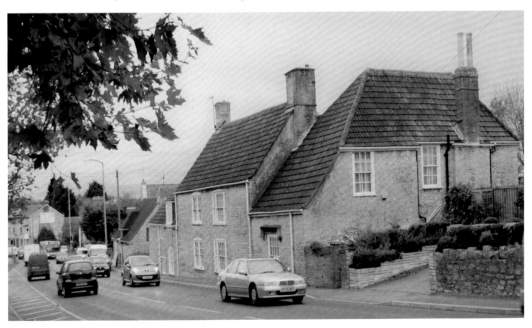

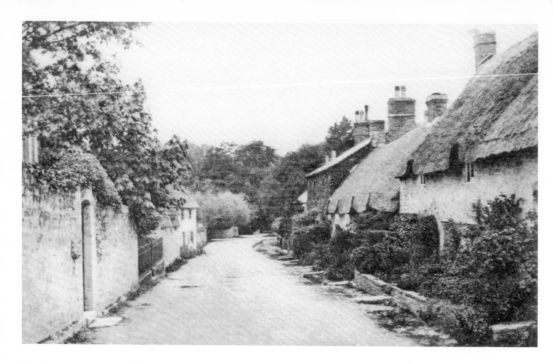

Stottingway was one of the ancient manors of Upwey and in Stottingway Street some of the houses and cottages on its southern side date from the late nineteenth century but some are earlier, dating from the seventeenth century and are still thatched. On the northern side, rebuilding has taken place and only one house appears to have remained the same for at least the last century. At the end of the street, Manor Farm followed by Upwey Manor which is in part, of Elizabethan origin with later additions of the seventeenth century and some Victorian, held in former times by the Gould family along with other manors of Upwey.

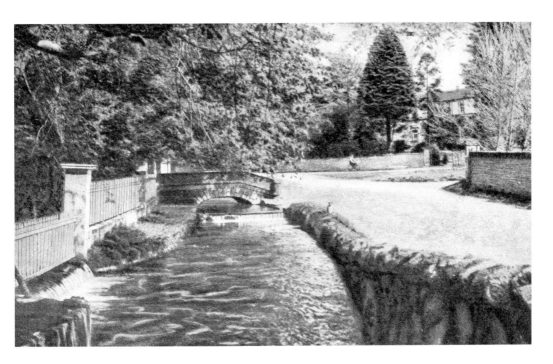

At the junction of Watery Lane, Stottingway Street and Church Street with the picturesque waterfall, the little bridge over the water leads into the grounds of Westbrook, a large house built by the Freke family in the early 1600s. Around the mid 1700s the house underwent major changes with the additions of wings enfolding the original building. A stable block was added around the same time. Across the road on the corner of Stottingway Street with Church Street, is Eastbrook, a Victorian house but built in an earlier style.

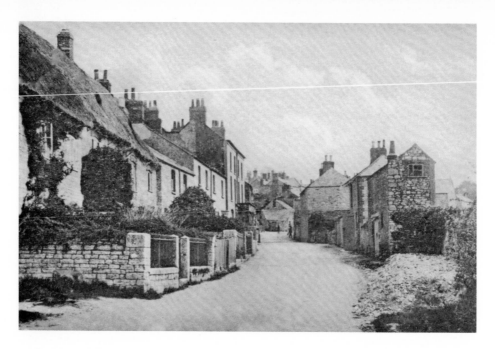

Elwell Street takes its name from another of the ancient manors of Upwey. This manor however, was part of the Liberty of Wyke Regis. The origin of the name Elwell is of that meaning 'healing well' which the Wishing Well was believed to be in ancient times. On the northern side of the street, the terrace of houses was all once thatched and the three storey houses near the end are of Georgian origin. The road was widened at this point in 1917. On the southern side, the buildings date from the early nineteenth century along with the Methodist chapel.

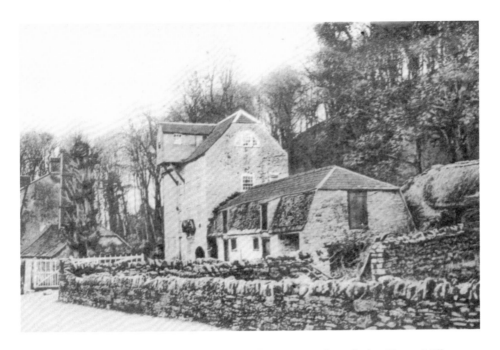

The Domesday Book records several mills along the River Wey but whether Upwey Mill was on the same site as today, is not certain. Upwey water mill has a date inscribed of 1802, though doubtless there was a mill on the site for many years before. In the early seventeenth century, the miller of Upwey was Edward Sprague and his three sons were some of the first settlers in Massachusetts, having sailed on the *Abigail* from Weymouth in June 1628, arriving in Salem in September. Upwey Mill has two sources of water, the main one from the River Wey behind it and another from the mill stream in front. The current owners of the mill now have their own hydro producing electricity from the power of the water.

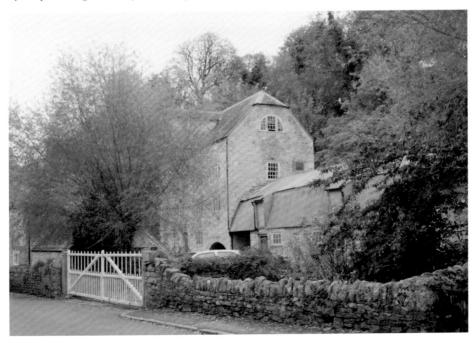

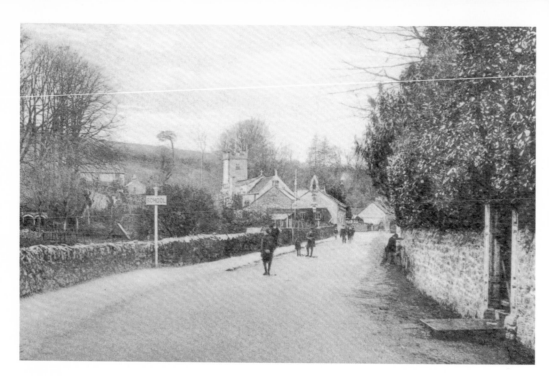

On the approach to the Wishing Well in Church Street, where in days gone by, horses pulled cart loads of visitors from Weymouth, the early Victorian school of 1840, built of local limestone, still looks much the same, although closed in 1965 and now serving as a village centre. The small lane to the side formerly provided direct access to the Wishing Well. The house close by was the school mistress's home. Almost opposite the old school there stands a row of cottages, at a right-angle to the road, of the early nineteenth century and beyond, a pair of the eighteenth century opposite the church of St. Lawrence, known as 'Windsbatch' and 'Wishing Well Cottage'.

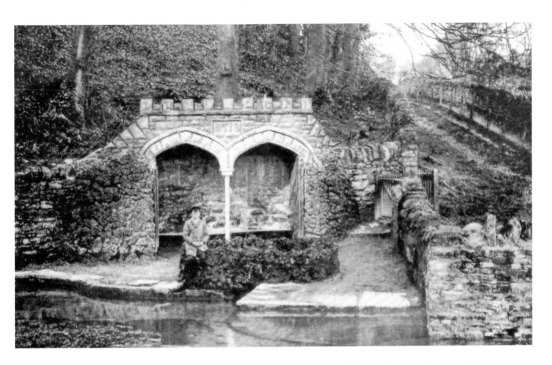

The Wishing Well, which is the spring from which the River Wey flows and gives Weymouth its name, was a favourite place of King George III where the clear waters were said to be good for medicinal purposes. It is said that a gold cup was kept at a nearby house for his majesty's use and it was later presented by a member of the Royal family for use as a presentation trophy at Royal Ascot. The arched seating area replaced an earlier wooden shelter and was built by Captain Gould whose initials appear above it and whose family owned the well and much of Upwey for centuries. The well was always popular with visitors and excursions from Weymouth ran regularly in the summer season. In more recent times, the Jubilee Gardens have been created in commemoration of Queen Elizabeth's Golden Jubilee.

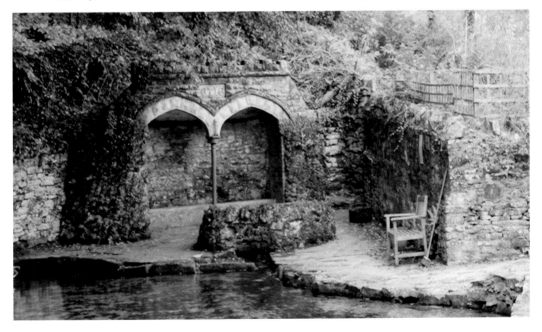

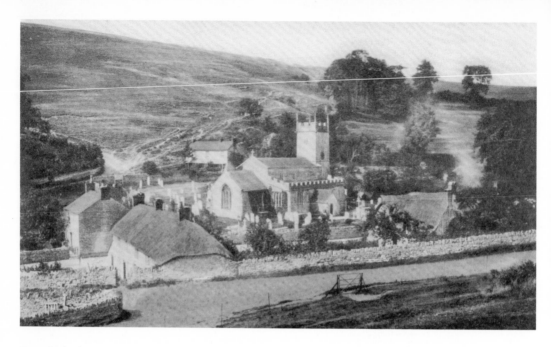

From high above on the hillside, the Church can be seen in its setting among the old cottages of the village, including the old schoolmistress's house. The church of St. Lawrence dates in part from *c*.1350 with the tower, north aisle and porch dating from around 1475. The remainder of the building is much later with the south aisle rebuilt in 1838 and the vestry and chancel added in 1907. In 1955 severe flooding, as a result of a huge downpour on top of the hills, left the church with watermarks 10 inches high on the pews. Many memorials to the Lords of the Manor families of Gould, Floyer and Freke are inside and outside the church. To the north of the church, past 'Windsbatch' and 'Wishing Well Cottage' is the old rectory, now named 'Batchfoot House' dating from around 1840.

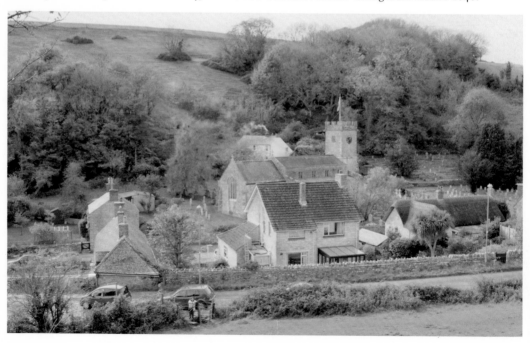

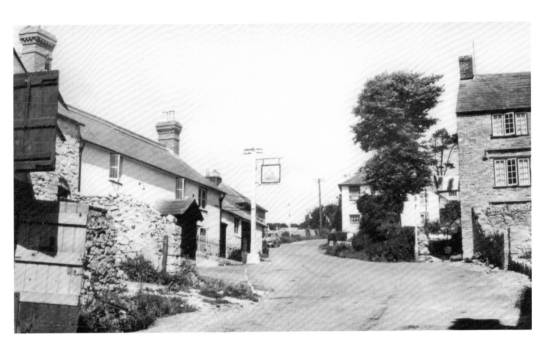

The Old Roman Road running down over the Ridgeway and through Upwey was the original route to Weymouth from Dorchester until 1824 when a new piece of road was constructed to the east to alleviate the steep gradient of using this road. The new piece of road is familiar today as the hairpin bend. The Ship Inn on the Old Roman Road, once a row of stone built cottages, with the former blacksmiths below it, surrounded by eighteenth and nineteenth century cottages and houses makes a rather picturesque scene.

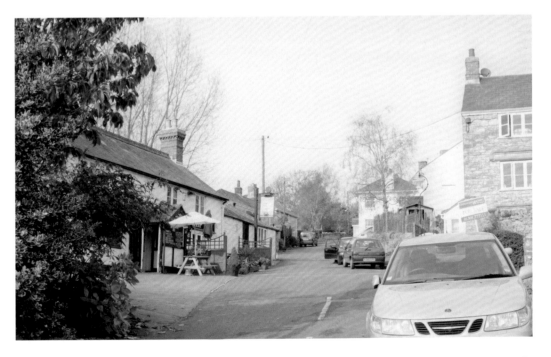

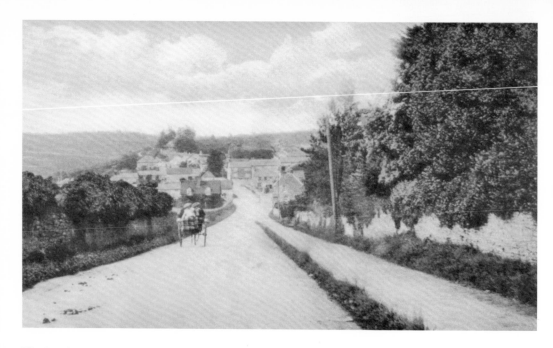

The Dorchester Road at Upwey looking towards the Old Roman Road has undergone many changes in the last century. The Royal Oak public house at the foot of the hill, built around the turn of the last century of stone with brick dressing, was demolished in 1968 for road widening. Some of the very old cottages still remain, hidden by trees behind a long low wall on the eastern side of the road.

Ridgeway with Upwey to the west and Bincombe to the east, with the tunnel of the railway line to Weymouth running first beneath the road and then over it via a bridge, is currently the main entrance to the Borough from Dorchester. Soon that will change and this part of the Ridgeway will once more become a quiet country area with its fine views of Weymouth and Portland. The notorious hairpin bend was constructed in 1824 with the aim of making the coaching route easier by avoiding the steep decline of the old Roman road. Soon a new relief road will be built which is already in the early stages of construction and the intention is to close off the current route over the Ridgeway.

Preston and Sutton Poyntz

Approaching Overcombe corner from Lodmoor on the old turnpike road there stood a tollhouse, demolished in 1959, once occupied by the Shorey family who ran a horse-drawn cab service. The original Preston Beach wall that the sea often breached in the winter was replaced in 1995 with a much higher wall sloping down on the road side. On the corner, the Overcombe Cafe was replaced by a block of flats in 1965 and opposite, the former petrol station now replaced by a hexagonal toilet block. Landslips caused several of the old Coastguard cottages to slip into the sea, of which now only two remain. The Nineteenth Cafe built on the edge of a small golf course in the 1930s became the Embassy Hotel and is now the Spyglass Inn. The road here leading to Bowleaze Cove was once the main road from Weymouth to Osmington until the Preston Road was built in 1812 via Chalbury Corner.

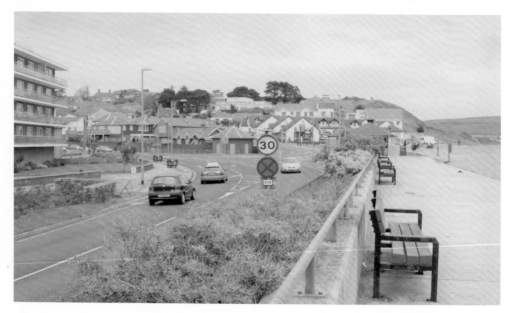

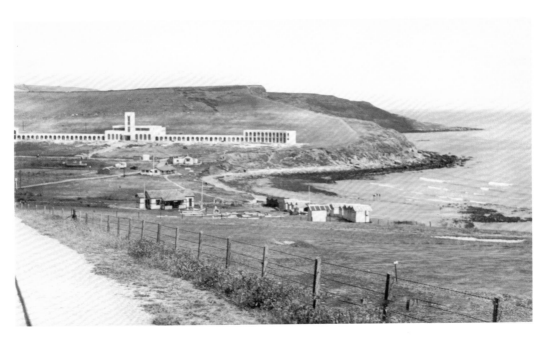

Above Bowleaze Cove, the remains of a Roman temple were discovered in 1834 at Jordan Hill. During the 1930s further excavations revealed a shaft in the south-east corner of the temple in which were found ritual deposits of bird bones, bronze coins placed between flat stones, pottery, a sword and a spearhead. Earlier views of the Cove show just a few beach huts on the cliff edge, but much of the cliff has since fallen into the sea. In 1937 the Riviera Hotel was built overlooking the Cove with another storey being added later, and in 1958 it became part of Fred Pontin's chain of holiday camps until 2000 when it was sold.

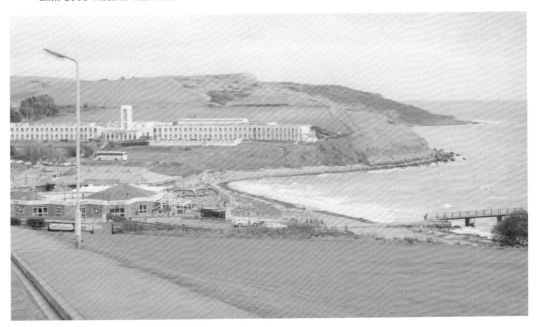

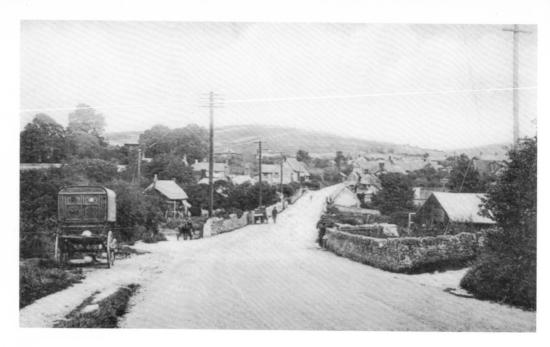

The entrance into the main part of the old village of Preston is via a road bridge of circa 1820 going over the River Jordan. Below the bridge lies the seventeenth Century Roman Bridge Cottage, much extended in the last century, and close by a quaint old packhorse bridge that was formerly thought to be of Roman origin, hence the name of the cottage. However, in the late nineteenth Century, it was decided by the antiquarians, the Rev. Talbot Baker, then vicar of Preston, and Mr F Warne, to be of Norman origin. The lane beside it leads to the Bridge Inn, formerly called the Swan and thatched and behind it, the old mill.

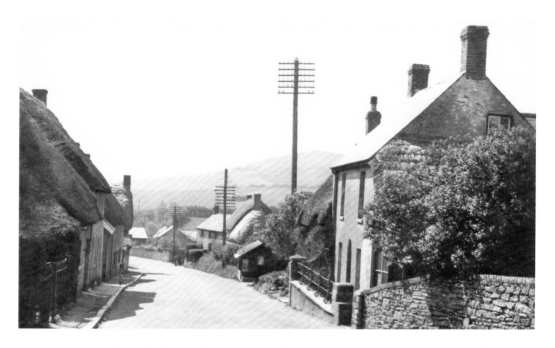

In the heart of the old village of Preston, these old cottages dating from around the mid eighteenth Century, hide between them a short lane leading to Manor Cottage, the former home from 1663 of John Wesley, an ejected clergyman and the grandfather of the founders of Methodism. His son Samuel followed in his footsteps and gained a living in Lincolnshire where his wife Susanna taught her methodical ways to the parishioners. Her sons, John and Charles, preached their mother's 'Methodism' and so the religion was founded along with the Society in 1728. Close by in the lane stands the former Victorian village school.

The thatched former Post Office, sideways onto the main road, records a date above the doorway of 1747. Across the main road that has been widened by the demolition of houses, Bridge Inn Lane wanders between a cluster of nineteenth Century cottages, leading to the River Jordan and the old mill.

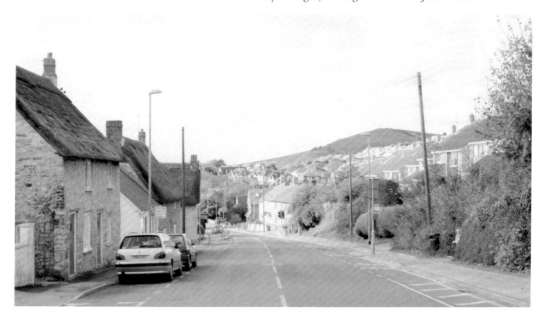

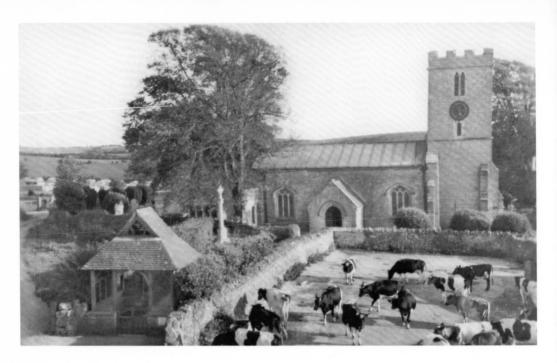

The ancient parish of St. Andrew's, Preston, united with the chapelry of Sutton Poyntz, included the Lodmoor area where it met with the boundary of the ancient parish of Radipole. Recorded in the parish register of the latter in 1582 the boundary is described as being at the 'great dike' which is in the vicinity of the Sea Life Centre. The parish church dates mainly from the fourteenth and fifteenth Centuries and the font bowl is of Norman origin. The south aisle was added during the sixteenth Century and the battlemented tower rebuilt using some of the fourteenth Century materials. The lych gate was constructed in 1910 from timbers of the old Courthouse of Sutton Poyntz which was destroyed by fire in 1908. The adjoining farm on whose land Roman remains were discovered in 1844 is now a holiday camp.

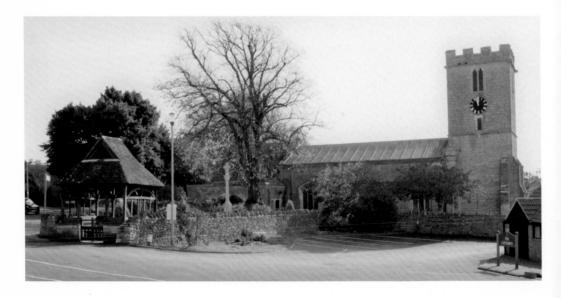

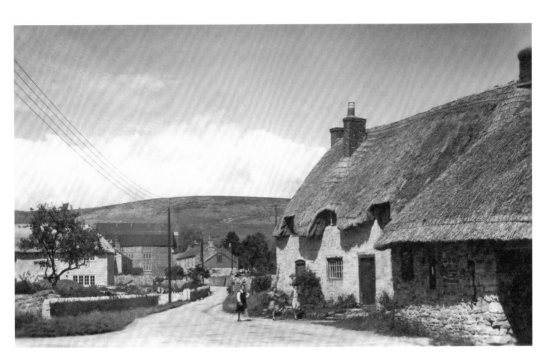

Sutton Poyntz takes the second half of its name from the Poyntz family who held the manor from around the twelfth century until there being no male heir it passed to Sir John Newburgh who had married Margaret Poyntz. The present mill built in the early nineteenth century replaced a stone-built structure and the original mill had stood on the site of a fourteenth century courthouse that Hugh Poyntz had converted to a water mill. In 1819 the mill was sold on the death of its builder, George Hyde, the land of the manor then being held by the Weld estate who continued to hold it until it was sold off in 1925. The old courthouse stood opposite the mill but was burnt down in 1908. Bellamy Cottage, standing on the island at the fork of the roads, was formerly two cottages called The Elms, the home of a blacksmith who had his smithy in front.

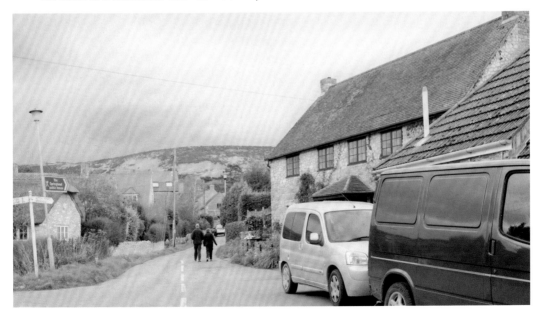

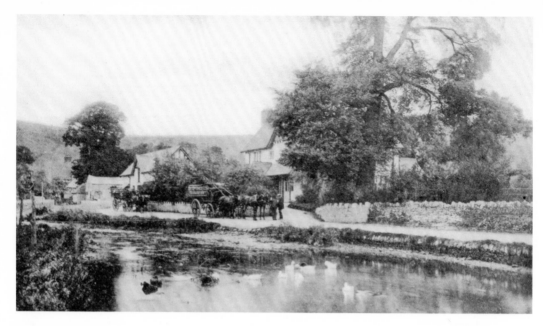

The Springhead Hotel, built in 1898, takes its name from the source of the River Jordan as does this area in general including the mill pond immediately in front of the building and the cottages on the opposite side. The cottages have mostly been rebuilt, but were all once thatched with two of them having been the Springbottom Inn and the corner cottage previously the village shop. Nearby is the Victorian water pumping station, built on the site of the former Upper Mill in 1855. In 1859, Brunel's ship, the *Great Eastern* was conducting trials around Portland when an explosion in a boiler blew off one of the funnels. The water company bought the funnel and put it to use as a filter for the spring above the pumping station.

The view from Preston Hill looking back towards Weymouth as the artist John Constable would have seen it on his visits to Osmington, is little changed in landscape but for the advent of camping and caravan holidays. On honeymoon in Osmington in 1816 Constable was inspired by the local scenery of the hills of Preston and painted 'Weymouth Bay' from Bowleaze Cove. The painting is now in the National Gallery. Quite fittingly, Weymouth has been described as 'England's Bay of Naples' many times in the past. With the sailing events of the 2012 Olympic Games taking place in Weymouth Bay, that claim will be put under the spotlight around the world and Weymouth will have more added to its already rich history.

Acknowledgements

With grateful thanks to the following for their help in the compilation of this book:
J. Holland and Son, Electric Palace, Alexandra Gardens; staff of the Hotel Rex; Andy
Hutchings; Mark Cleaver; Mark Anderson; Weymouth St. Paul's Harriers; Mark Vine.

Attempts have been made to trace copyright where appropriate and we apologise to anyone
who may have inadvertently been omitted from these acknowledgements.

About the Author

Debby Rose is descended from a family that can be traced back for almost 500 years in
Dorset, where much of the family still live today, mainly in the Weymouth area. Her Wyke
Regis born grandfather told her many a story when she was a child and it was from those
stories that she gained an appreciation for Weymouth's history as well as the family history.
Her direct line ancestors married at Radipole in 1791 and several members in the family
tree were smugglers of old. Debby's interest in Weymouth's local history grew to include her
founding a website in 2004 in order to share Weymouth's rich history with others:
www.weymouth-dorset.co.uk

Over the years she has had many articles published in various local and family history
journals and magazines, was a co-compiler of the Somerset and Dorset Family History
Society's *The Histories of some Somerset and Dorset Parishes – Snapshots and Spotlights*
published in 2005, of which society she also ran a service for 11 years and has held
various posts within. She also edited and helped Mark Vine with his book *The Crabchurch
Conspiracy* published in 2004. Most recently, she wrote *Westham Over the Bridge of Time*,
published in August 2008.

Debby is very grateful to Mike of GraphicPhoto-Arts: www.graphicphoto-arts.com for
stepping in to rescue this book when it looked likely to fail due to circumstances beyond
her control. This he did in a very timely and professional manner without complaint.